IMAGES
of America

WASHINGTON
COUNTY

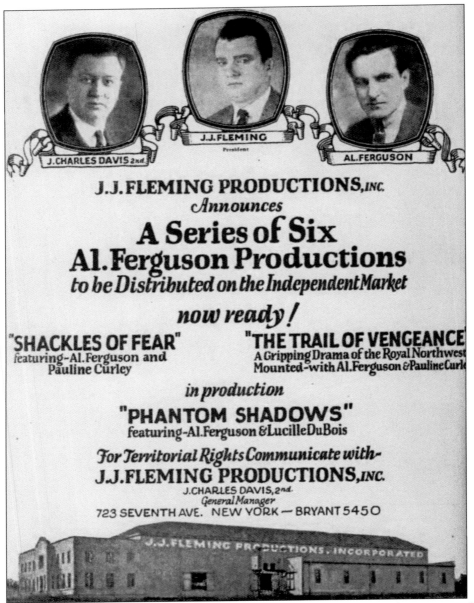

PREMIUM PICTURE PRODUCTIONS, BEAVERTON. This 1924 advertisement, found in an issue of the movie trade publication *Exhibitors Trade Review*, features Premium Picture Productions' president John J. Fleming, general manager J. Charles Davis, and the featured films' star, Al Ferguson. The company's two-story silent movie studio, seen at bottom, was located in Beaverton. More information about the Beaverton-based movie studio can be found on pages 90 and 91. (Arthur Sommers.)

ON THE COVER: LOGJAM PREVENTION, TUALATIN RIVER. "Log drivers" are making sure the free-floating logs on the Tualatin River do not get wedged together and stop moving downstream to the mill. These men are working for Joseph Hare's Hillsboro Lumbering Company. (Courtesy of Washington County Museum.)

IMAGES
of America

WASHINGTON
COUNTY

Arthur Sommers and Karen Kearns

ARCADIA
PUBLISHING

Published by Arcadia Publishing
Charleston, South Carolina

Printed in the United States of America

Library of Congress Control Number: 2018962699

For all general information, please contact Arcadia Publishing:
Telephone 843-853-2070
Fax 843-853-0044
E-mail sales@arcadiapublishing.com
For customer service and orders:
Toll-Free 1-888-313-2665

Visit us on the Internet at www.arcadiapublishing.com

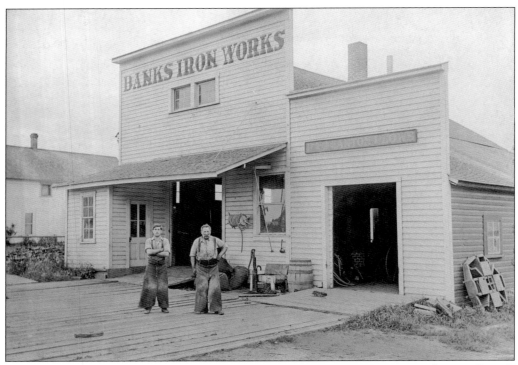

IRONWORKS, BANKS. This c. 1912 photograph shows Banks Iron Works owner Albert Mills with his son Fred Mills (left). In the 1910 US Census, Albert Mills is listed as a blacksmith in Banks; however, in the 1920 Census, he is listed as a policeman in Forest Grove. The sign above the open door on the right reads, "P&O Canton Plows," which stands for Parlin & Orendorff of Canton, Illinois. (Courtesy of Washington County Museum, 16,803.)

CONTENTS

ACKNOWLEDGMENTS

Appreciation is extended to Liza Schade, Judy Gates Goldmann, Debi Knox, Winnifred Herrschaft, Christine Swenson, and Nathanael Andreini for their suggestions on improving this book. Most of the images used were selected from the collection at Washington County Museum, which has over 30,000 photographs; those images will have the museum's initials (WCM), as well as control numbers, at the end of their captions. Many other images are from the personal collection of author Arthur Sommers, and those are identified as AJS. The Washington County Museum was not responsible for the development of this book. The two coauthors are solely responsible for the final product. The authors of this book have agreed that all their royalties earned on book sales will be donated to the Washington County Museum.

INTRODUCTION

Washington County is in the northwestern corner of Oregon. It is the second most populous county in Oregon behind Multnomah County, which is located on Washington County's eastern border. Hillsboro is the seat of Washington County and is the fifth largest city by population in Oregon.

Washington County includes most of the Tualatin Valley, a basin formed by the Tualatin River, which slowly cuts a path from west to east to join the Willamette River at West Linn. The county is bordered by the Coast Range to the west and north; on the east by the basalt-filled Tualatin Mountains (or West Hills), which separate the valley from Portland; and on the south by the Chehalem Mountains.

The Tualatin name is derived from the Atfalati band of the Kalapuya Indians who once lived in the area. They camped seasonally throughout the valley and hunted game, traded for salmon, and gathered important trade plants, like camas (a member of the asparagus family) and wapato (a tuber about the size of a small potato). The Atfalati used to meet at special sites to trade, marry, and settle affairs. The most famous of these meeting sites was at a grove of oak trees known as Five Oaks in Washington County.

Similar to Indian tribes all over North America, diseases such as measles and smallpox introduced by Europeans ended up devastating Oregon's native Indian populations. These disease outbreaks in the Pacific Northwest occurred during the exploration and fur trade eras of the 1770s through the 1830s. By the time the first missionaries and early settlers began to form churches and schools in the region in the 1840s, most of the remaining Atfalati—maybe as few as 65 survived the ravages of disease—lived near Wapato Lake around the area where Gaston is now located. Native American women played a role in establishing good trade relationships by intermarrying with mountain men and fur trappers. These early interracial marriages were seen in Washington County with the Joseph Meek and Robert Newell families, which are discussed in chapter two.

The silk hat was invented in 1825 in Florence, Italy, and it immediately affected the fur trade in beaver pelts in the Oregon Country. Top hats made from silk quickly replaced top hats made from beaver fur. In 1827, Hudson Bay Company governor George Simpson ordered the addition of lumber manufacturing and shipping to the company's fur trade business. He argued that trees were the future of the company, not fur. The Hudson Bay Company conducted logging operations in the 1830s through the 1840s in the Pacific Northwest. The early settlers coming into the Oregon Country in the 1840s and 1850s had the Hudson Bay Company's example to follow in starting their own logging operations. A settler could file for a Donation Land Claim, clear the acreage of trees, sell the trees to an existing mill, or maybe even establish their own lumber mill. The late 19th century saw scores of both small and large lumber mill operations throughout Washington County.

The Provisional Legislature of Oregon Territory created Tuality County (Twality is an alternative spelling) on July 5, 1843, at a meeting in Champoeg. Champoeg was an important town in the 1840s and 1850s, but was destroyed by a flood in 1861 and never rebuilt. The area is now Champoeg State Park. Tuality County is one of the four original counties in the Oregon Territory. It was bordered on the far north by latitude 54 degrees 40 minutes, which is the source for the famous "Fifty-Four Forty or Fight" slogan that James Polk used in his presidential campaign of 1844. By 1844, the Columbia River was made the northern boundary of Tuality County with Clatsop County having been created from Tuality County's western half. In 1846, the United States and Great Britain signed the Oregon Treaty, which established the 49th parallel as the international border between territory claimed by the United States and territory claimed by Great Britain.

The 1846 Oregon Treaty confirmed Great Britain's claim on the hundreds of miles between the 49th parallel and the James Polk threatened boundary of 54 degrees 40 minutes, being the southern boundary of Alaska, which was owned by Russia until 1867. In 1849, the Oregon Territorial Legislature changed the name of Tuality County to Washington in honor of Pres. George Washington. Washington County would obtain its present boundaries in 1854 with the creation of Columbia County to the north and Multnomah County to the east. In 1859, Oregon was accepted as the 33rd state in the Union.

Although Tuality County's provisional government was established in 1843, a fully functioning county government was not organized until 1845, when three county judges having probate and administrative authority, a treasurer, and a sheriff were appointed. The first election of county officers was held in 1846. Over 100 years later, the voters of Washington County approved a home rule charter at a general election in 1962.

The town of Columbia was selected as the seat for Washington County in 1850. Later, Columbia was renamed Hillsborough for early pioneer David Hill, and in 1858, it was modified again to the simpler spelling of Hillsboro. After meeting in two area church buildings, a dedicated county headquarters building was built of logs in 1852. A brick courthouse was completed in 1873 and remodeled in the early 1890s. A new courthouse was built in 1928 to replace the brick building.

As Oregon entered statehood in 1859, people in Washington County needed a better way to transport their goods to local markets and into the city of Portland. Roads that followed the old Indian trails proved muddy in rainy weather and almost impossible to navigate via wagon. Planked roads were built, and planks were even installed on streets in the county seat of Hillsboro. Peter Scholl and John Taylor operated early ferries across the Tualatin River, while Jesse Boone built a cable ferry across the Willamette near his claim in Wilsonville. Steam navigation made a minor impact at first but lasted for only a few years, as the Tualatin River channel was very shallow and had to be constantly dredged, which was an expensive task. Samuel Galbreath built the first bridge across the Tualatin River. The bridge area became the site for a town called Bridgeport. That town evolved into the city of Tualatin.

The Oregon & California Railroad came to Hillsboro in 1871, opening up the Tualatin Valley to a much more effective and efficient form of transportation for agricultural foodstuff, lumber products, and people. The failure of steam navigation on the Tualatin River and the difficult dirt roads had people welcoming the arrival of the railroad. James and Ellen Smock granted the Portland & Willamette Valley Railway (P&WVRR) a right-of-way through their land in 1885. The coming of the railroad with a train depot was a catalyst for residents of Smockville to lobby for a change to their town's name. The name Sherwood was chosen, and the US Postal Service started delivering mail there in 1891. Noted railroad developer Joseph Gaston was an initial investor in the P&WVRR and is also the namesake for the town of Gaston, which is about 20 miles west of Sherwood.

Most of Washington County's larger towns had their streets paved and water systems installed after 1910. By that time, Washington County was a hub of agricultural production, with a list of crops that included hops, orchard fruits, berries, wheat, flax, nuts, and dairy. The Oregon Nursery Company (the town of Orenco's namesake) became a huge producer of fruit trees and berries for farmers on the West Coast, but the company went out of business during the 1929 stock market crash and resulting Great Depression, with the company's land eventually being sold off.

World Wars I and II both affected the region economically, as government contracts called for spruce and Douglas fir lumber production by the millions of board feet. Latino migrant laborers took care of the farm fields while American men went off to fight. As a response to the new frozen-food industry, companies like Reser Foods began in the 1950s and have become large employers and community supporters.

The latest industry to push Washington County forward into the future is modern technology. Tektronics built a manufacturing facility at Barnes Road and Sunset Highway in Washington County in 1950, and in the following decades, an influx of other technical-based companies followed suit. California-based Intel arrived in Washington County in 1974 and now has five large facilities, called campuses. Some of the other technology companies in the county include Electro

Scientific Industries, Lattice Semiconductor, FEI Company, TriQuint Semiconductor, Solar World, Planar Systems, and EPSON. The nickname "Silicon Forest" is often applied to the area.

Washington County has been one of the fastest developing areas in Oregon in recent decades. Nike world headquarters came to the Beaverton area in 1990 and has provided thousands of jobs. The 1990s saw a growth spurt of 42.94 percent in the county's population. The 2011 population of 536,370 marked an increase of over 20 percent since 2000. The development of a large electronics industry during the last three decades has contributed significantly to the economy of the county. Other principal industries are agriculture, manufacturing, and food processing. Logging is still somewhat important in Washington County, as it is in much of Western Oregon. There are over 1,300 companies associated with current logging operations in the state of Oregon.

The authors never intended to include an image from each of the over 70 named communities in Washington County. What they did attempt was to use interesting images from as many different communities as possible to tell the story dictated by the different chapter titles. The reader should discover an abundance of seldom seen images in this book.

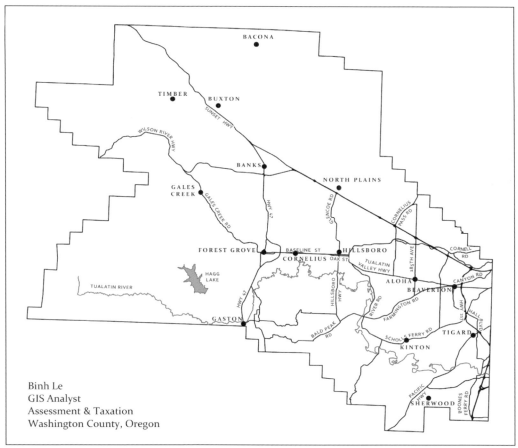

WASHINGTON COUNTY MAP. Since it would have become too crowded and difficult to read, this map of Washington County does not include all of its communities and roads. The northern boundary of Washington County is not parallel to the global latitudes, which is why it is not parallel to the top border of this map. There are 30 counties across the United States that share the name of Washington. (Courtesy of Binh Le.)

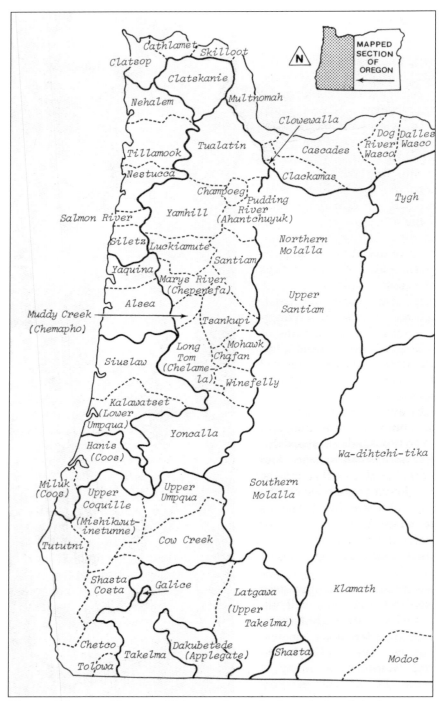

INDIAN TRIBES, WESTERN OREGON. This map shows the boundaries of the home grounds for the Indian tribes of Western Oregon. Toward the top of the map is the Tualatin territory of the Atfalati tribe, who were also referred to as Tualatin. The Tualatin boundaries on the map are similar to those of present-day Washington County. (Courtesy of Stephen Dow Beckham.)

One

NATIVE AMERICANS

The Kalapuya were the major Native American tribe in the northern part of the Willamette Valley. Its people lived in tribal territories that contained numbers of related and like-speaking, but basically autonomous, villages. The Atfalati people were members of the Kalapuya tribe and were located in the Tualatin Valley of Washington County (see map on facing page). Its members engaged in a hunter-gatherer lifestyle. The Atfalati had approximately two dozen villages in present-day Washington County, including Chachemewa near Forest Grove, Chalawai near Lake Wapato, Chakeipi close to Beaverton, and Chakutpaliu in the Hillsboro area.

The primary sources for food included deer, elk, camas root, wapato, fish, berries, and various nuts. To encourage the growth of the camas plant and maintain habitat beneficial to deer and elk, the tribal members regularly burned the valley floor to discourage the growth of trees, a common practice among the Kalapuya. A small grove of oak trees was known to have been used by the Atfalati as a ceremonial meeting site. That grove of five oaks was located on the old Arnold Berger farm (originally the Zachary Donation Land Claim) north of Highway 26 and east of Helvetia Road. Another site favored by the Indians was called Lake Wapato, which was formed by a beaver dam adjacent to the town of Gaston. Another large lake formed by a beaver dam was Lake Lousignont north of Forest Grove near Verboort. The resulting lakes covered hundreds of acres. Both were drained in the early 20th century to create more farmland for European settlers.

Before contact with Westerners, the Atfalati were known for wearing adornment such as feathers on their heads. Both men and women had pierced earlobes and noses, hanging beads and dentalium shells from the piercings. The Atfalati were not known to tattoo their bodies, but compared with the Kalapuya peoples farther to the south, the Atfalati practiced a more severe form of infant head flattening. The Atfalati kept slaves, who could sometimes purchase their freedom with horses; however, the Atfalati raised fewer horses overall than tribes to the east.

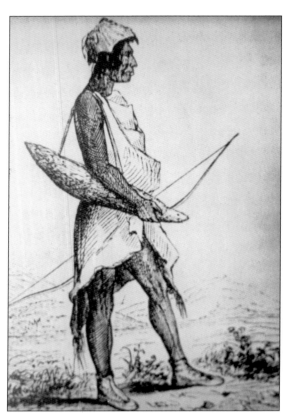

ATFALATI MALE, WASHINGTON COUNTY. Alfred Agate, a member of the Wilkes Expedition to the Tualatin Valley in 1841, made this drawing of a male member of the Atfalati tribe. His body covering and his head cover were made from furs. (WCM, 3,435.)

FIVE OAKS, WEST UNION. When this 1930s photograph was taken, Arnold Berger owned the land. Generations earlier, this group of oak trees had been a ceremonial meeting site for Atfalati tribal members and later also came to be used by white settlers for celebrations. All the original oak trees in this group are now gone save for one. Four replacement oaks have been planted. (WCM, 19,151.)

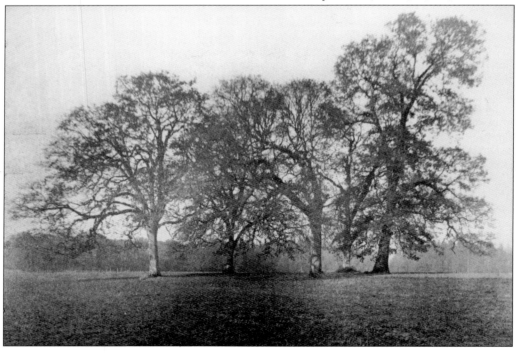

MAP OF WAPATO LAKE, GASTON.
This is a map from John
Christy's January 2015 report
on the historical conditions at
Wapato Lake. He created the
map by merging 1850s surveyor
plat maps from four adjoining
townships. When pushed off
their lands to the north, the
surviving Atfalati preferred to
settle near the lake. (AJS.)

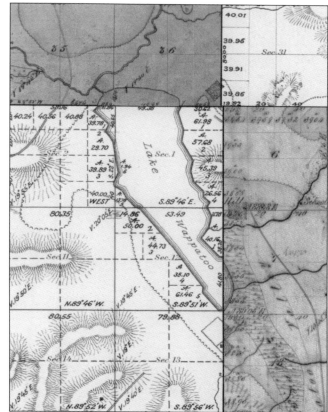

WAPATO LAKE, GASTON. The
glare of the sun on the waters
of Lake Wapato is very bright.
This photograph, taken before
the lake was drained, shows
how close the community of
Gaston was to the northwestern
shore of the lake. (WCM, 654.)

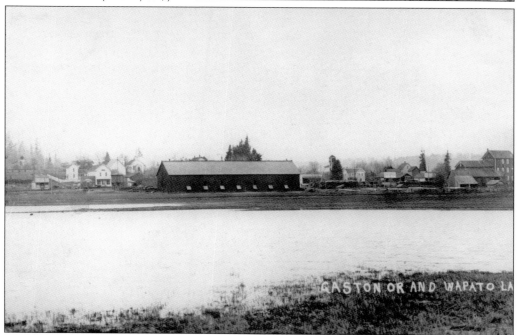

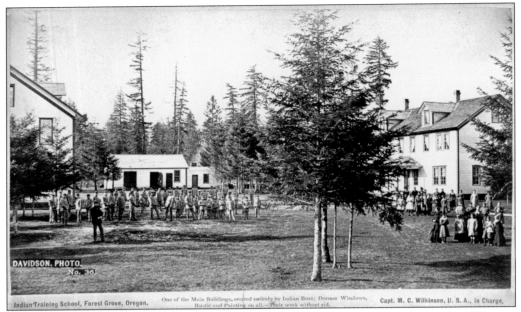

INDIAN TRAINING SCHOOL, FOREST GROVE. Attempts to assimilate native populations into Western culture were often made around the world in the 19th and 20th centuries. In Washington County, the Indian Training School was established in Forest Grove. This photograph shows some of the buildings on the school's campus, which was located on the grounds of Pacific University. (WCM, 11,027.)

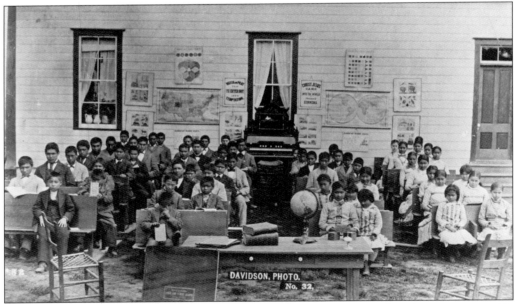

INDIAN SCHOOL CLASS, FOREST GROVE. A simulated classroom seems to have been set up outside for this photograph. A photographer from the Davidson photography studio in Portland was sent to the school to document it in 1882. (WCM, 11,024.)

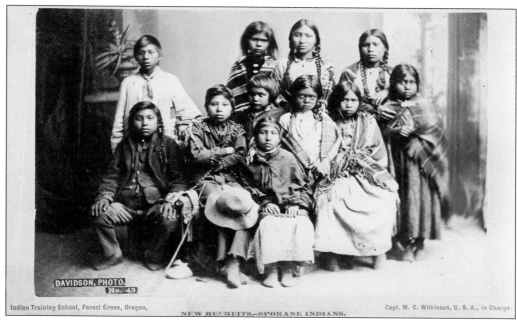

DAVIDSON, PHOTO.
No. 43.

Indian Training School, Forest Grove, Oregon,
NEW RECRUITS.—SPOKANE INDIANS.
Capt. M. C. Wilkinson, U. S. A., in Charge.

NONCOUNTY INDIANS, FOREST GROVE. Indians from outside of Washington County were sent to the school at Forest Grove. Between the years 1880 and 1885, approximately 275 Indian children from over 30 different tribes attended the school. In 1885, a new training school was opened in Salem. (WCM, 11,056.)

NEZ PERCE, WASHINGTON COUNTY. Virginia, the wife of Washington County pioneer Joseph Meek, is seen here. She was a Nez Perce tribal member from Idaho, as was Kittie, the wife of Robert Newell. The Meeks and the Newells (see pages 17 and 18) arrived in Washington County in 1840. (WCM, 3,235.)

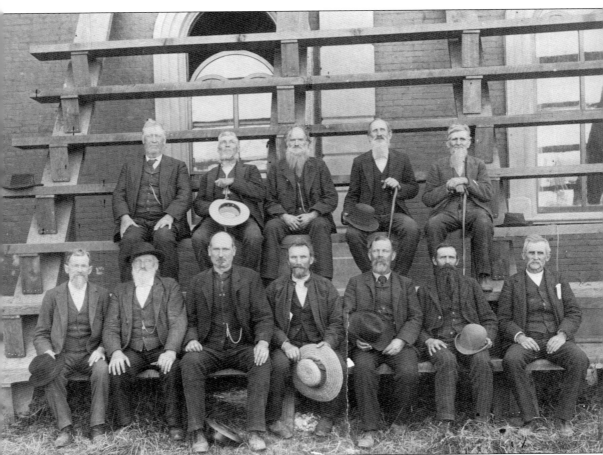

INDIAN WARS VETERANS, HILLSBORO. Many of Washington County's surviving Indian Wars veterans would gather for annual reunions. This 1893 photograph shows some on the substantial bleachers built adjacent to the courthouse. These bleachers were used for other group photographs (see page 37). In the first row, Jabez Wilkes is sitting second from right. Sitting above Wilkes is Isaac Butler. Thomas Ramsey Cornelius is at far left in the second row. Oregon's Indian Wars is an umbrella term used to cover the individual wars conducted between those of European ancestry and the Native Americans during the 1850s–1870s. Some of the individual wars have names, like the Cayuse War, the Rogue River Wars, the Bannock War, the Yakima War, the Nez Perce War, and the Modoc War. These wars did not take place within the boundaries of Washington County. (WCM, 1,508.)

Two

EARLY PIONEERS

Some of the earliest people of European ancestry to settle in the Washington County area of the Oregon Country were fur trappers from America and Canada. By 1840, the fur trading industry was in decline, and some of the trappers made their way to the Tualatin Valley area to start new lives as farmers and loggers. Two of those men were Joseph Meek and Robert Newell. In 1840, both men and their Indian wives made their way along the Columbia River and into the Tualatin Valley to settle a land claim. French Canadian Catholic priests and nuns and American Protestant ministers were missionaries who also made their way to the Oregon Country. They established missions throughout the territory, and many also founded schools.

Most pioneers wishing to settle in the Oregon Country came from the East over the Oregon Trail. The "Great Migration" of emigrants began in 1843. The long and difficult journey started in Missouri and took the pioneers west to the end of the trail in Oregon City. To promote settlement in the Pacific Northwest, the federal government offered Donation Land Claims to men who were citizens and at least 18 years old. If they were married, their wife could also make a claim. Before 1850, the amount each could claim was 320 acres. Between 1850 and 1855, the amount was reduced to 160 acres. In 1862, the Homestead Act was passed to encourage people to settle the West. Many of these early arrivals settled in communities with other families from their home country. Two such communities in Washington County are Helvetia and Bethany, which were settled mostly by the Swiss and Germans.

Some of the pioneers in this chapter are well-recognized figures from Washington County's past. Other less well-known pioneers who also contributed to the development of Washington County are included. There are many towns, schools, parks, and streets in Washington County that are named after these early pioneers, including the towns of Hillsboro, named for David Hill; Cornelius, named after Thomas Ramsey Cornelius; and Tigard, named for Charles Tigard.

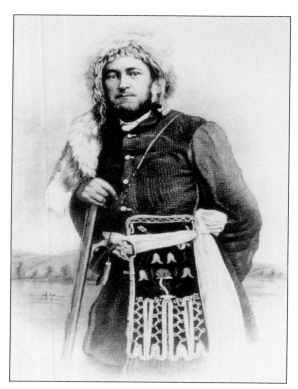

MEEK AND NEWELL, HILLSBORO. Joseph Meek was born in Washington County, Virginia, in 1810. The image at left shows him in his fur trapping clothes. He also appears in the image below, standing next to the shorter Robert Newell. Both men were fur trappers, but the decline of the fur trade led them and their Native American wives to settle just north of what would become Hillsboro in the Tualatin Valley. Meek and Newell both participated in the 1843 meeting at Champoeg that led to the formation of a provisional government in Oregon. Newell would come to have a home in Champoeg. Meek would serve as a Washington County sheriff and as a US marshal. Newell served in the Provisional Legislature from 1843 to 1849. Newell was appointed a peace commissioner during the Cayuse Indian War and became the Indian agent for tribes south of the Columbia River. (Left, WCM, 1,025; below, WCM, 18,566.)

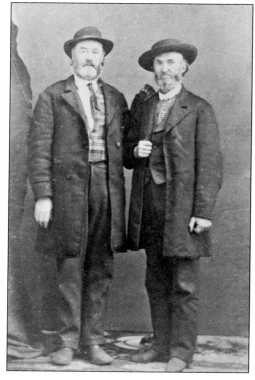

CHARLES MCKAY, GLENCOE. Charles McKay was an employee of the Hudson Bay Company. At the 1843 meeting in Champoeg, he voted for the Oregon Country to become part of the United States. McKay helped establish the town of Glencoe, which he named in remembrance of his home nation of Scotland. Glencoe thrived until the arrival of the railroad, which created the nearby town of North Plains, dooming Glencoe. (WCM, 944.)

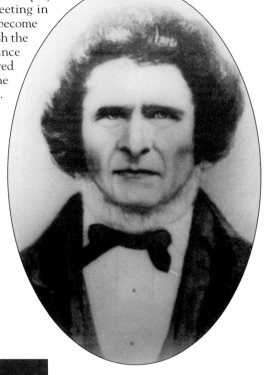

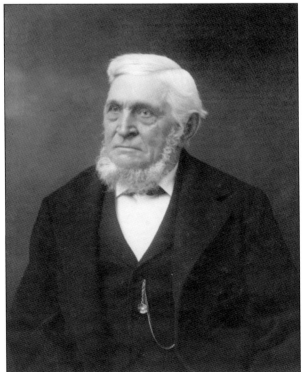

THOMAS OTCHIN, WEST UNION. Thomas Otchin also worked for the Hudson Bay Company. He arrived in the Tualatin Valley in 1842 and purchased a 640-acre farm for $16. He spent time in California during the gold rush and returned to Oregon with some black walnuts, which he planted on his farm. Those trees were recognized in 1976 as possibly being the oldest bearing walnut trees in Oregon. (WCM, 998.)

COL. THOMAS RAMSEY CORNELIUS, CORNELIUS. Thomas Cornelius arrived in Oregon in 1845 at the age of 18 and settled a Donation Land Claim. He was a veteran of the Indian Wars and was active in the Oregon legislature. The town of Cornelius was named after him to honor his many contributions to the community. Cornelius Pass Road was built to connect the Tualatin Valley with the Columbia River. (WCM, 379.)

WILLIAM MERRICK BROWN, HILLSBORO. William Brown is credited with building the first jail in Washington County. He also constructed the first gallows and coffin for a convicted murderer in 1856. Brown was a deputy sheriff in Washington County from 1866 to 1870. He also served as a school clerk, a road supervisor, and a justice of the peace. (WCM, 228.)

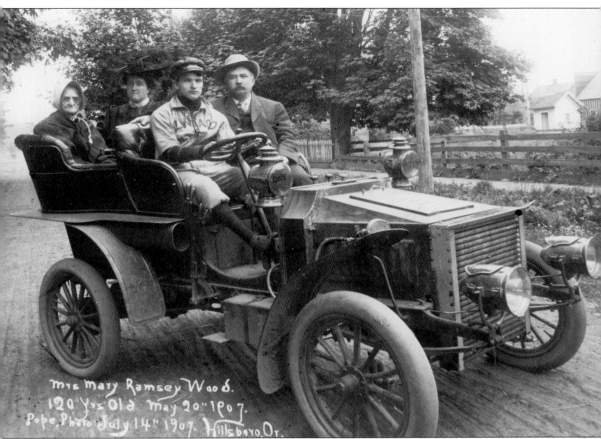

Handwritten on image: *Mrs Mary Ramsey Wood. 120 Yrs Old May 20" 1907. Pope Photo July 14" 1907. Hillsboro. Or.*

SMITH, IMBRIE, AND WOOD, HILLSBORO. This 1907 photograph shows Elmer Smith in the driver's seat, and next to him is James Imbrie. Mary Ramsey Wood is in the back on the left with an unidentified woman on the right, who is likely Mary Ramsey Wood's daughter Catherine Reynolds. The Imbries were pioneers who traveled the Oregon Trail and established a prosperous farm in Hillsboro. A McMenamins brewpub on Imbrie Drive now uses some of the Imbrie farm buildings. Elmer Smith graduated from medical school in 1910 and opened a hospital in downtown Hillsboro. Writing on this image states that Mary Ramsey Wood's age was 120 years. A *Hillsboro Argus* article from 1949 states that her relatives claimed in a letter to the *Argus* that the family bible had an entry for her birth in 1787. As a widow, Mary came to Oregon on the Oregon Trail. She settled in Hillsboro and married John Wood around 1853. They opened a hotel in downtown Hillsboro. Mary Wood died in 1908. Her advanced age was much celebrated but cannot be definitively proven. (WCM, 1,581.)

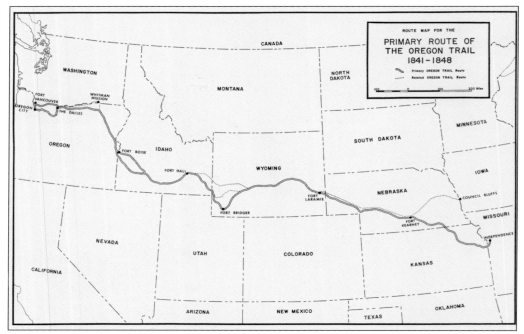

MAP OF THE OREGON TRAIL. The Oregon Trail started in Missouri and its end point was in Oregon. Many of Oregon's early settlers came down from the Canadian territory or came west over the Oregon Trail. It would typically take about five months for a wagon train to make the 2,000-mile trek from Missouri to Oregon. (WCM.)

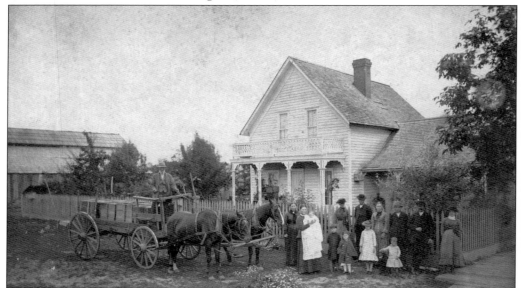

THE MOORE FAMILY, HILLSBORO. Michael and Mary Moore were both pioneers on the Oregon Trail. Michael arrived in 1844, and Mary and her mother, Lucinda, arrived in 1845. After marrying in 1847, the Moores settled in Hillsboro. Michael was a teamster and is seen standing in the wagon. He carried the surveyor's chains used to survey Hillsboro in 1850. He also took part in forming the local school district and was the director for a time. (WCM, 964.)

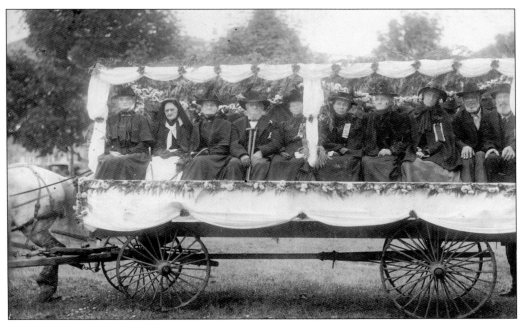

PIONEERS' FLOAT, HILLSBORO. These Oregon Trail pioneers of the 1840s and 1850s are seated on a parade wagon for a celebration in Hillsboro prior to 1909. From left to right are Catherine B. Reynolds, Mary Ramsey Wood, Mrs. Stewart, Thomas Otchin, Susan J. Brown, Mary Moore, Mrs. Riley Killigan Ennis, ? Walker, Thomas Tucker, and unidentified. (WCM, 1,063.)

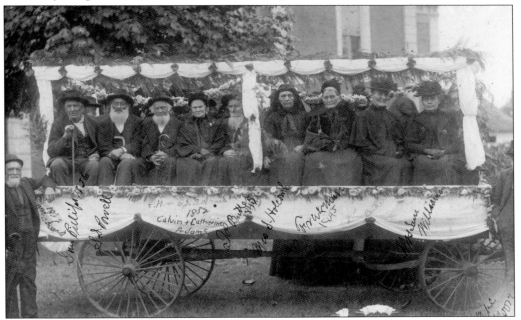

ANOTHER PIONEERS' FLOAT, HILLSBORO. This is another parade wagon with Oregon Trail pioneers of the 1840s and 1850s. From left to right are William Adams, Dan Phillips, Stephen D. Powell, Calvin Adams, Catherine Adams, J.P. Butler, Mrs. S. Holcomb, unidentified, Mrs. Butler, Mrs. Sam Williams, and Mike Moore (partially cropped). (WCM, 1,064.)

JABEZ WILKES, BANKS. Jabez Wilkes traveled the Oregon Trail with his parents, Peyton and Anna Wilkes, arriving in Oregon in 1845. In 1855, he enlisted to fight in the Yakima Indian Wars. He married his first wife, Mary Jane Jackson, in 1856. Jabez was a carpenter and built wagons, farming tools, furniture, and most of the coffins used in the local cemetery. His son Orville appears numerous times in subsequent chapters in this book. (WCM, 9,933.)

DANIEL GAULT, HILLSBORO. This photograph of Daniel Gault was taken in 1874. Gault was a newspaper man, educator, and politician. He attended Tualatin Academy in Forest Grove and Willamette University in Salem. In 1872, he taught school in Hillsboro and was superintendent of public schools for Washington County from 1874 to 1878. In 1892, he became owner and editor of the *Hillsboro Independent* newspaper. (WCM, 661.)

Three

EVOLUTION OF TRANSPORTATION

Originally, there were paths between Indian villages, ceremonial sites, food gathering areas, and the like. Those dirt paths evolved into dirt roads upon the arrival of European settlers with their horses, oxen, and wagons. The rainy weather of the Pacific Northwest turned those dirt roads into muddy quagmires. One solution to the muddy roads dilemma was to harvest the abundant trees for lumber to create plank roads. Using planks to improve roads was a technique used in the heavily forested Eastern states. The most famous plank road in Oregon was called Canyon Road, which was built in 1856 to link the Tualatin Valley with the city of Portland. Planks even came to be used in the streets of Hillsboro and in other Washington County communities. The coming of the railroads, beginning in the 1870s, made the interurban plank roads mostly obsolete, as the railroads provided a much faster and more reliable means of transportation. At first, the railroads' locomotives were steam powered, but the introduction of electricity led to the development of electric-powered railroads in the early 1900s. Numerous creeks and rivers required ferries to be used at many different locations to cross the waters. Bridges were built later to replace the ferries. The increased use of bicycles led bicycle clubs to lobby for better roads in the late 19th and early 20th centuries. A little later, the automobile enthusiasts took up the bicyclists' call for better roads. Soon, asphalt and concrete were used to pave the dirt roads, providing a much better surface. Airplanes also arrived in Washington County, and Dr. Elmer Smith was the first resident to own and fly a plane. Dr. Smith ended up buying land outside the city limits of Hillsboro for a dedicated runway. That land eventually evolved into the Hillsboro Airport.

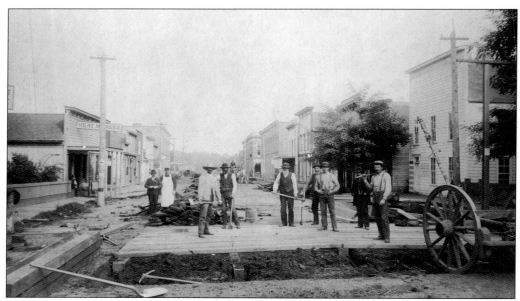

INSTALLING PLANKS ON SECOND STREET, HILLSBORO. This photograph shows a crew of men installing planks on Second Street. The planks were typically about three inches thick. In the 1890s, only portions of Second Street and Main Street had wooden planks. (WCM, 1,180.)

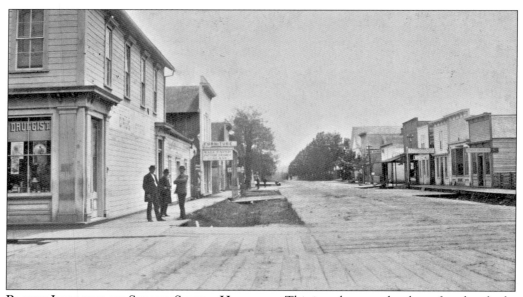

PLANKS INSTALLED ON SECOND STREET, HILLSBORO. This is a photograph taken after the planks had been installed on Second Street. The planks run down the middle of the street, and wooden crosswalks can be seen joining the sidewalks with the planked street. (WCM, 1,721.)

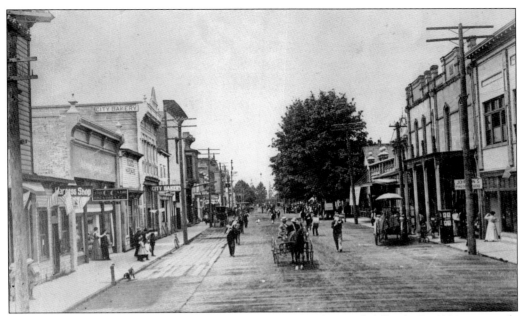

PLANKS ON MAIN STREET, HILLSBORO. Muddy streets made travel difficult. In 1894, an article in the *Hillsboro Independent* called for planking the streets of Hillsboro. Who should pay for the installation and upkeep of the planks was an issue through the years, as reported by an article in the *Hillsboro Independent* of 1903. Regardless, planks were laid on parts of Main Street and parts of Second Street. (WCM, 1,443.)

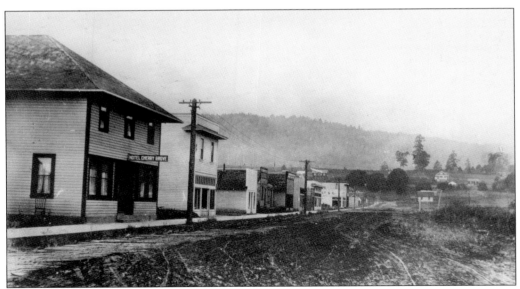

PLANKED STREET, CHERRY GROVE. The small town of Cherry Grove, near Gaston, laid down a narrow band of planks adjacent to the sidewalk running in front of the businesses on the town's main street. Identification of the community is made easy by the small sign hanging above the entrance to Hotel Cherry Grove. (WCM, 13,278.)

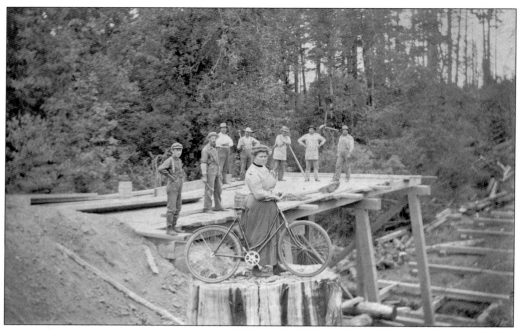

BRIDGE ACROSS ROCK CREEK, HILLSBORO. A small crew of men is constructing a wooden bridge across Rock Creek just outside of Hillsboro. A woman is posing with her bicycle. Bicycles gave women an increased sense of freedom and are credited with contributing to the push for women's suffrage. (WCM, 18,425.)

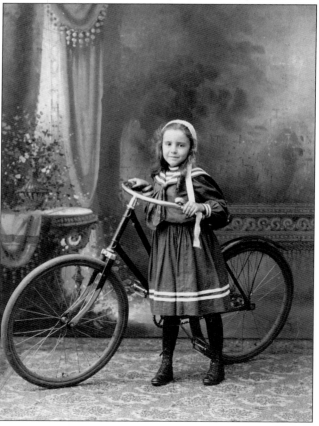

LUCY WEATHERRED, HILLSBORO. Lucy is pictured with her first bicycle. She was the daughter of Thomas Weatherred, who was a salesman, according to the 1910 US Census. Lucy's older sister Tennessee became a teacher. (WCM, 1,552.)

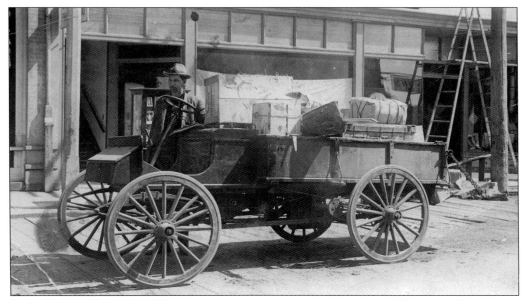

FIRST TRUCK, HILLSBORO. The first combination automobile/truck in Hillsboro is shown here. Note that the rear wheels are driven by a chain from the motor. Early automobiles used a lot of technology from bicycles. Many bicycle manufactures developed prototypes of automobiles. Note that the truck is parked on planks. (WCM, 048.)

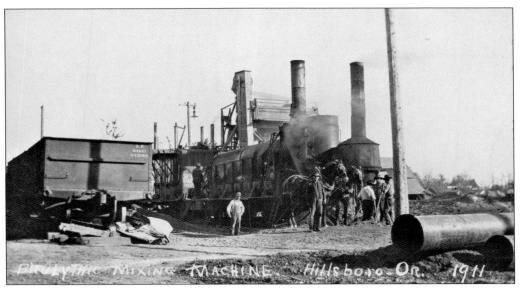

PAVING THE ROADS, HILLSBORO. Dirt roads and planked roads gave way to roads being paved with various substances. In 1901 and 1903, Frederick Warren was issued patents for an early hot-mix form of paving materials. The concept was to produce a mix that could use a more "fluid" binder than that used for sheet asphalt. This patented material became known as "bitulithic," as noted on this image. (WCM, 11,869.)

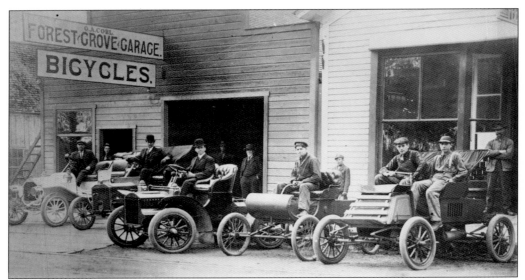

AUTOMOBILES, FOREST GROVE. Automobiles and owners are lined up in front of Oliver Augustus Corl's garage and bicycle shop. Grant Hughes is in a Buick at far left. The second car from the right is an Oldsmobile with garage owner Oliver Corl at the wheel. Tommy Hughes is in a Rambler on the far right. James Rasmussen is standing in his store's doorway at far right. (WCM, 050.)

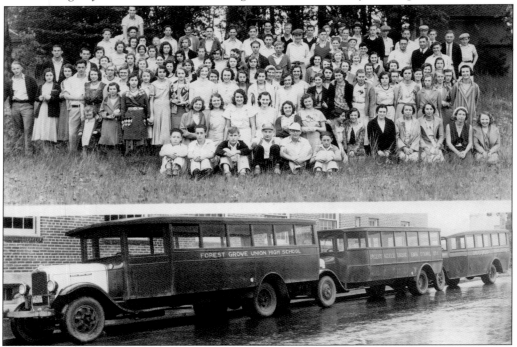

SCHOOL BUSES, FOREST GROVE. These c. 1930 photographs show a group of students and their school buses. Walking or riding a horse was the most common way to get to school prior to buses. Buses made attending school much easier for the students; however, there were increased costs to the school districts. Today, many kids are dropped off and picked up at school by their parents. (WCM, 13,478.)

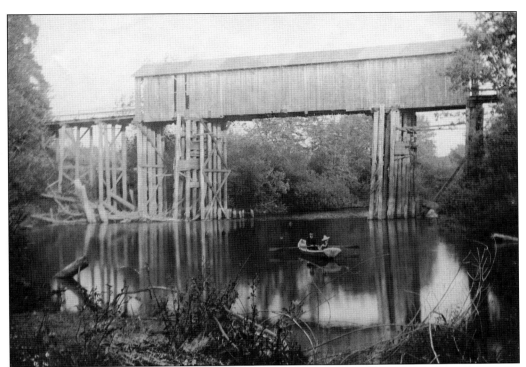

BRIDGE ACROSS THE TUALATIN RIVER, SCHOLLS. The small community of Scholls is famous for its ferry across the Tualatin River (Scholls Ferry Road). This photograph shows that a wooden bridge was also used before it was torn down in 1907. (WCM, 9,356.)

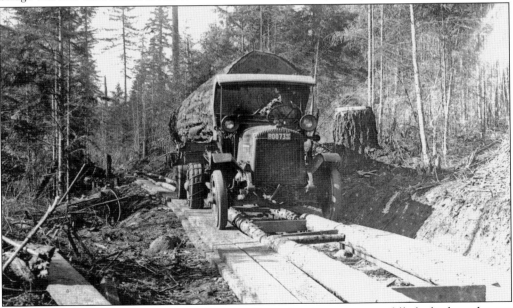

PLANKS IN THE FOREST, WASHINGTON COUNTY. Once the giant trees were felled, plank roads were sometimes placed down to help haul the logs out of the forest. This truck also has chains on a pair of rear tires for added traction. Trucks soon replaced teams of horses or oxen. (AJS.)

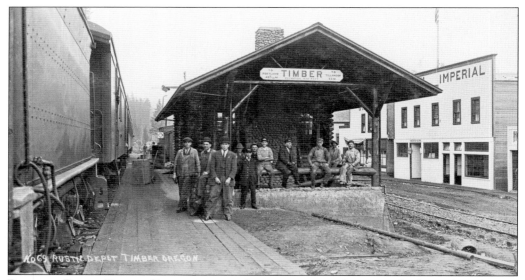

RAILROAD DEPOT, TIMBER. Since trains were the primary means for moving both people and cargo, railroad-adjacent communities of almost any size would have a depot. Gradually, the railroads relinquished their duties to cars and trucks. The log depot at Timber was built in 1915; prior to that time, the depot at Timber was a pair of empty railroad boxcars. The Hotel Imperial, seen at right, was owned by Beauford Creps and Frank Minto. (AJS.)

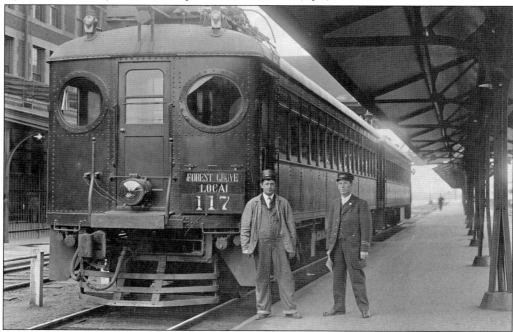

ELECTRIFIED SOUTHERN PACIFIC, PORTLAND. Two electrified cars are hooked together to form a Southern Pacific Railroad Company train, labeled the *Forest Grove Local*. These cars with the round windows are not to be confused with the cars used by the Oregon Electric Railway company, which had rectangular windows. Those two companies ran tracks more or less parallel through the center of Washington County. (WCM, 3,075.)

Four

SMALL BUSINESS

For the purpose of this book, a small business is defined as one employing a small number of people. The term small business also applies to professionals, such as doctors, druggists, and dentists. The demarcation between a small business and a big business in this book is not exact. While writing this book, it was sometimes difficult to distinguish between a small business and a big business, especially for the occupation of farming. Most farms were single-family operations with maybe one or two hired hands to help in the harvesting of the crops. There were also large farming operations (see the Hare family's operation in chapter five) with large land holdings and many people needed to work the land and bring in the crops.

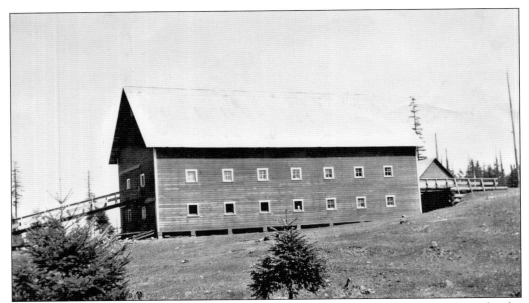

HOFFMAN BARN, BACONA. Bacona is named after Cyrus Bacon, the first postmaster for the community. It is situated at a little above 2,000 feet in elevation at the northern boundary of Washington County. This photograph is of Peter Hoffman's barn. Hoffman, an immigrant from Denmark, owned a sawmill. (WCM, 28,036.)

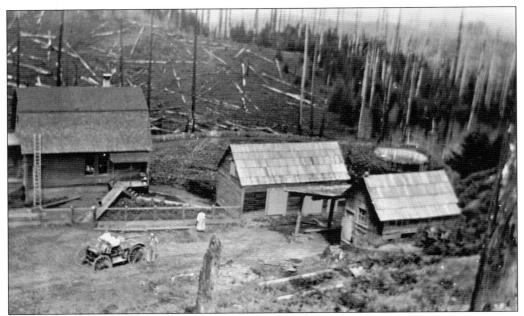

JEPPESEN'S HOMESTEAD, BACONA. Soren Jeppesen emigrated from Denmark in 1889. Just a decade later, he was the official enumerator for the 1900 US Census in his local precinct. His occupation was listed as a brick mason. He and Peter Hoffman lived on adjacent properties in Bacona. (WCM, 28,032.)

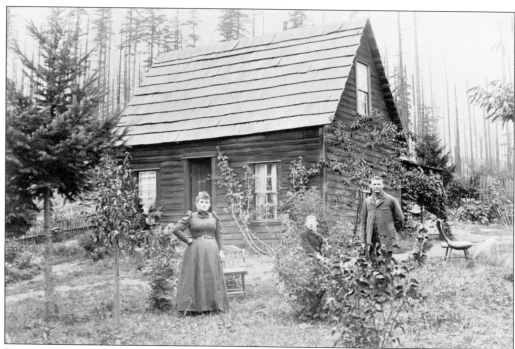

THE ROE FAMILY, BACONA. Daniel Roe; his wife, Alice; and their son Glenmore are standing outside their small home in Bacona. Alice Roe was of the Bacon family. (WCM, 18,967.)

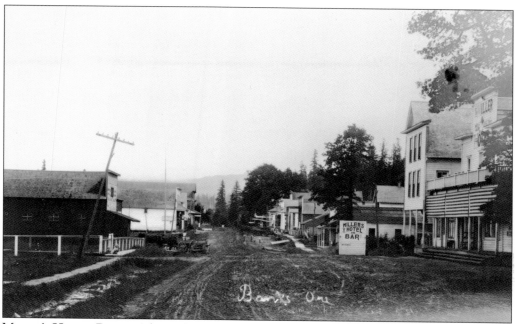

MILLER'S HOTEL, BANKS. John Miller operated a hotel and saloon in Banks around 1910. He was listed in the 1910 US Census as a saloonkeeper. A large sign advertising his business establishment can be seen in the street outside his hotel/bar. (WCM, 18,509.)

Market Street, Banks. This c. 1910 photograph shows a few small businesses bordering Market Street in the little town of Banks. The Hotel Banks is on the left down toward the end of the street. It was a common practice at the time to put the word "hotel" before the name. (WCM.)

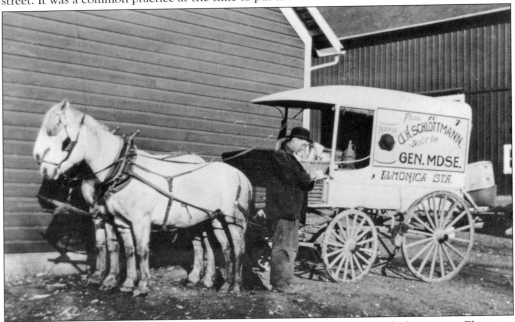

Delivery by Wagon, Elmonica. A. Henry Schlottmann's delivery wagon for his store at Elmonica Station is shown here. A land owner gave permission to the Oregon Electric Railway to run its tracks through his property on the condition that the railroad station would be named after his daughters Eleanor and Monica, thus Elmonica Station. There is a modern Elmonica stop on the MAX line at 170th Avenue. (WCM, 16,327.)

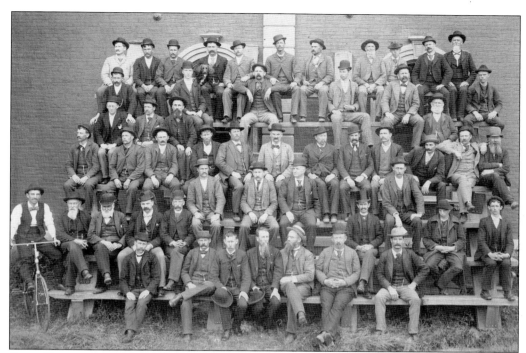

SMALL BUSINESSMEN, HILLSBORO. In 1893, many of the businessmen of Hillsboro gathered together to pose for this photograph at the county courthouse. Note the dog lying across the lap of local saloon owner Edward Lyons, fourth from left in the top row. (WCM, 239.)

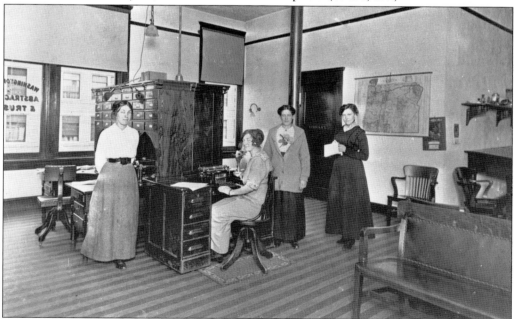

WASHINGTON COUNTY ABSTRACT & TRUST, HILLSBORO. Four women are working in the offices of attorneys George Bagley and William Hare. The two men had rooms Nos. 1, 2, and 3 in the Shute Building. Hare appears on page 71. (WCM, 12,230.)

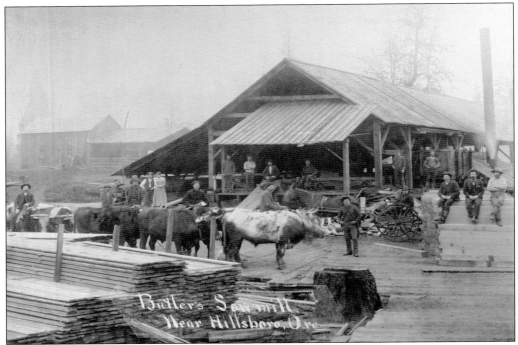

SAWMILL, HILLSBORO. Isaac Butler owned a sawmill near Hillsboro. It was sited where Baseline Road crossed over Rock Creek near the community of Orenco. During the turn of the last century, scores of small and large sawmills were operating in Washington County. (WCM, 543.)

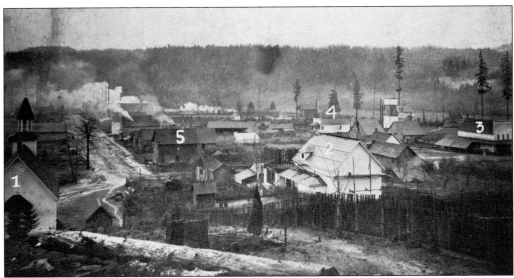

NUMBERED BUILDINGS, BUXTON. Luckily, someone took the time to identify some of the buildings in this 100-year-old photograph of Buxton. Building No. 1 was the Presbyterian church, No. 2 was Charley Paterson's home, No. 3 was John Henry Rinck's store, No. 4 was Bob Simpson's saloon, and No. 5 was the Elk Horn Hotel. (WCM, 242.)

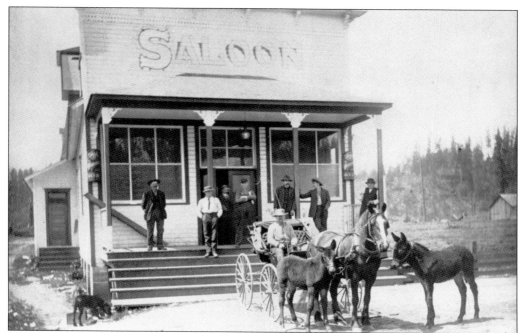

SIMPSON'S SALOON, BUXTON. Charles Lazott is in his buggy in front of the Simpson Saloon in Buxton, which is labeled No. 4 in previous image. Lazott has a pair of donkey siblings tethered to his horse in front of the saloon. On the left side of the saloon is a door leading into the outhouse. (WCM, 344.)

LAZOTT'S FARM, BUXTON. This is a photograph of Charles Lazott's farm on Buxton Road in Buxton. The slope of the hill prompted Lazott to build a platform at his property's front gate to facilitate people getting on and off a horse and in and out of a wagon. (AJS.)

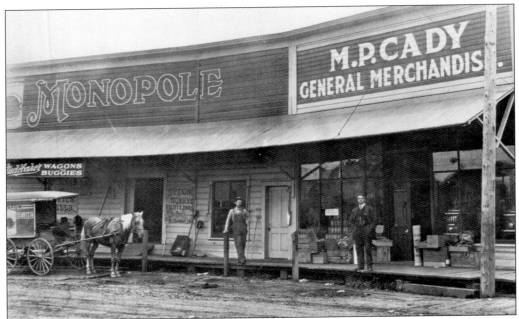

MASON CADY, BEAVERTON. In this photograph of Mason Cady's business, a sign at far left shows he was a dealer for Studebaker wagons and buggies. By 1916, Mason Cady was an agent for Studebaker and Chevrolet automobiles. Though his automobile business was in Beaverton, he claimed Hillsboro as his place of residence on the 1930 US Census. (WCM, 15,772.)

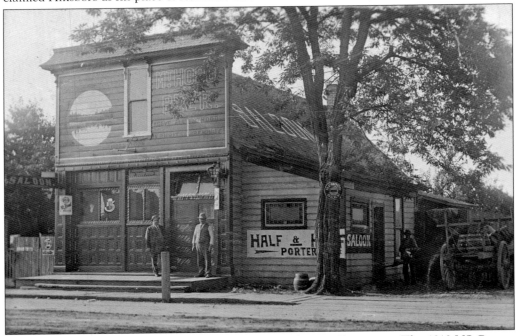

ROSSI'S SALOON, BEAVERTON. This is August Rossi's saloon in Beaverton. The 1910 US Census lists Rossi's occupation as saloonkeeper. In 1910, he had a wife, daughter, and three sons. Rossi was also a farmer. (AJS.)

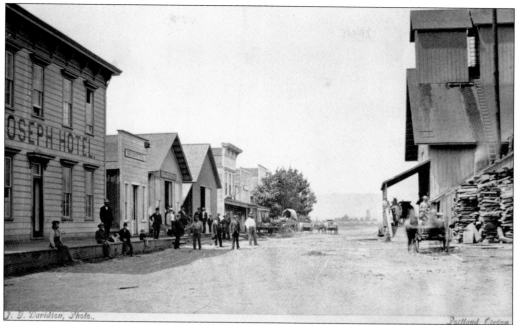

MAIN STREET, CORNELIUS. Small businesses crowd each other along the main street of Cornelius in this 1875 photograph. The St. Joseph Hotel at left had three different owners in three years around the time this photograph was taken. Thomas Cornelius owned the large warehouse on the right. (WCM, 386.)

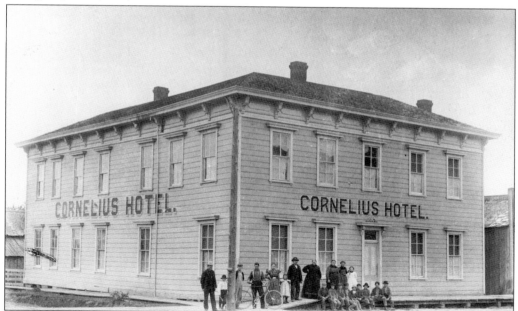

HOTEL, CORNELIUS. Benjamin Cornelius and his son Thomas were instrumental in growing the area originally called Free Orchards into an actual community, which assumed the name Cornelius. The two-story hotel building pictured here is the same hotel called the St. Joseph in the previous image. (WCM, 898.)

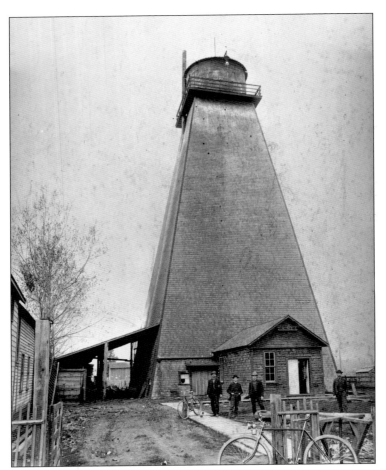

POWER PLANT, HILLSBORO. Standing in front of Hillsboro's water tower and electric power plant, Orville Wilkes is second from the left. This building was home to the Hillsboro City Water & Light Works. A similar tower is seen adjacent to the Laughlin Hotel in Forest Grove on page 46. (WCM, 1,259.)

POWER PLANT RECEIPT, HILLSBORO. This 1904 receipt is from the Hillsboro City Water & Light Works. Oregon Condensed Milk Co. (see page 61) paid its bill of $20.85 on January 26, 1905. (WCM.)

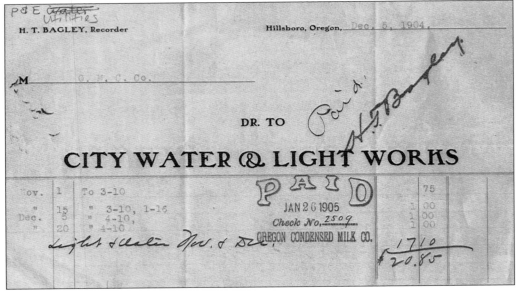

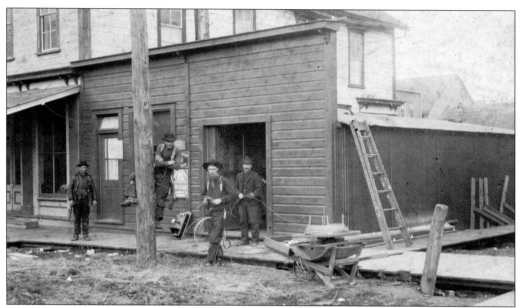

STRINGING PHONE LINES, HILLSBORO. Orville Wilkes was a busy man. In this photograph, he has climbing spurs on his boots and is getting ready to climb the utility pole to string a telephone line at the top. Wilkes was a manager of the Independent Telephone Company of Hillsboro, according to a *Hillsboro Argus* article dated October 14, 1909. (WCM, 1,562.)

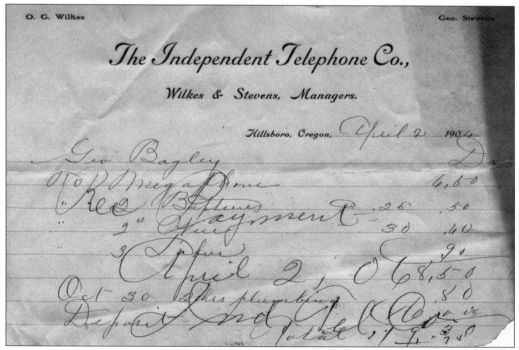

INDEPENDENT TELEPHONE COMPANY, HILLSBORO. This receipt from the Hillsboro Independent Telephone Company shows that Orville Wilkes and George Stevens were the managers of the phone company. Orville Wilkes was the son of pioneer Jabez Wilkes, seen on page 24. (WCM.)

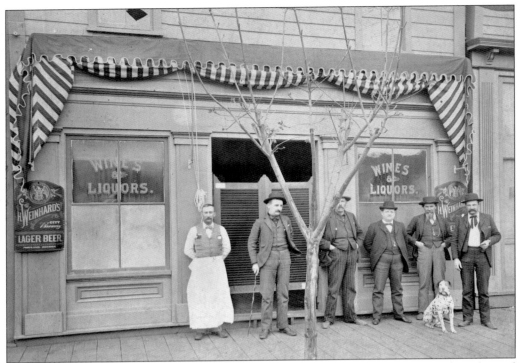

WILEY'S SALOON, HILLSBORO. The exterior of Wiley's Saloon is seen here. William Wiley inherited the saloon from his father, Richard Wiley. The man at far right is identified on the back of the photograph as William Wiley. Note the dog posing with the men. (WCM, 1,154.)

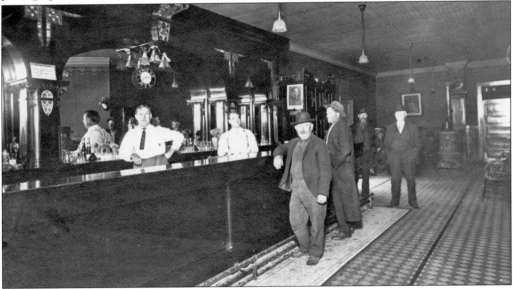

INTERIOR VIEW OF WILEY'S SALOON, HILLSBORO. This photograph is of the interior of Wiley's Saloon. Wiley's was located on Second Street between Washington and Main Streets. Richard Wiley was the original owner and owned it as early as the 1860s. Decades later, he passed the saloon on to his son William. (WCM, 1,156.)

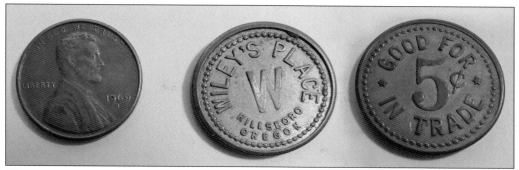

Wiley's Saloon Tokens, Hillsboro. Pictured are the front and back sides of a metal token issued by Wiley's Saloon. A modern penny is used for size comparison. Tokens were given to customers in hopes of luring them back to exchange the token for another drink and then stay to pay for even more drinks. The hobby of collecting vintage tokens is called exonumia. (AJS.)

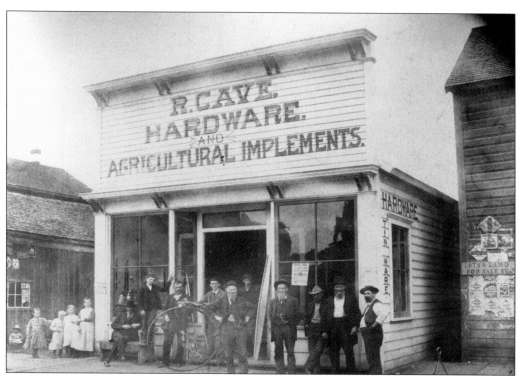

Cave's Hardware, Hillsboro. Beginning in 1878, Riley Cave operated a hardware store in Hillsboro. He also served as a magistrate in Hillsboro for 14 years. Cave came to Oregon with his parents in 1843. The high-wheel bicycle in the image had many names, including boneshaker and penny-farthing, at the turn of the last century. (WCM, 268.)

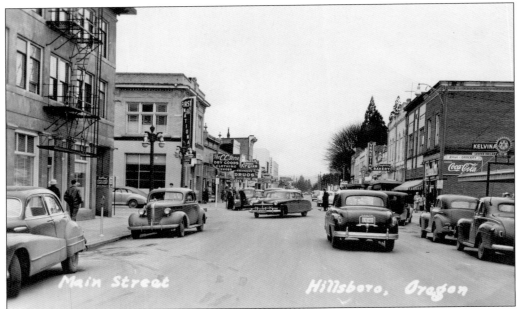

WORLD WAR II ERA, HILLSBORO. Pictured is Main Street in Hillsboro. The Venetian movie theater (for sale in 2018) is on the right; the First National Bank, where Dr. Smith's hospital was once upstairs, is on the left; and down from the bank and across from the Venetian is the office of the *Hillsboro Argus* newspaper, which was at that location for decades. (AJS.)

LAUGHLIN'S HOTEL, FOREST GROVE. This postcard, mailed in 1911, depicts Bedford Laughlin's hotel. The sender noted on the back that he walked 54 miles from Tillamook to reach Forest Grove to look for work. The adjacent tower is Forest Grove's waterworks. (AJS.)

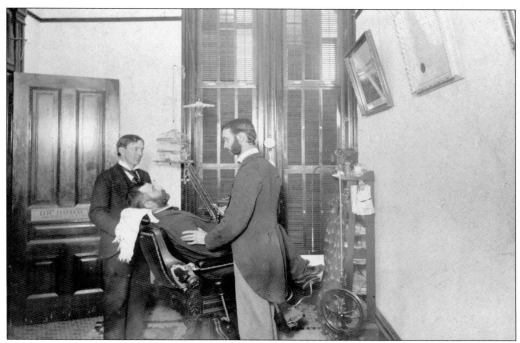

DENTIST OFFICE, HILLSBORO.
This photograph shows the
interior of Dr. Charles Benjamin
Brown's dentist office, located in
the middle upstairs room of the
building on the northeast corner
of Second and Main Streets.
From left to right are Warren
Dobins, William DeWitt Smith,
and Dr. Brown. (WCM, 207.)

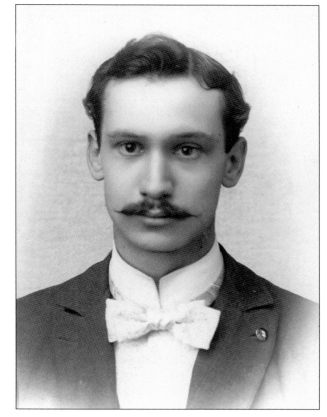

DENTIST, HILLSBORO. Dr. Charles
Benjamin Brown had this
portrait taken at the J. Fortin
photography studio of Huntington,
Oregon. His family came to
Oregon in 1852. (WCM, 206.)

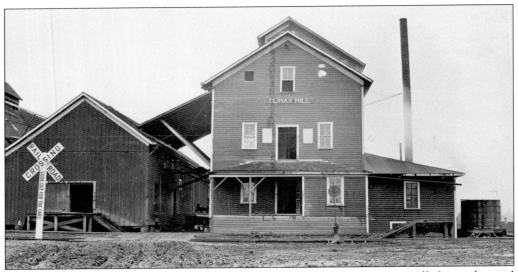

CLIMAX MILL, HILLSBORO. The Climax Mill was a flour mill, not a sawmill. It was located adjacent to the railroad tracks for ease of shipment. The *Hillsboro Argus* of February 2, 1905, has a large advertisement for "Moss Rose" and "Great Raiser" flours produced by the Climax Mill. (WCM, 1,034.)

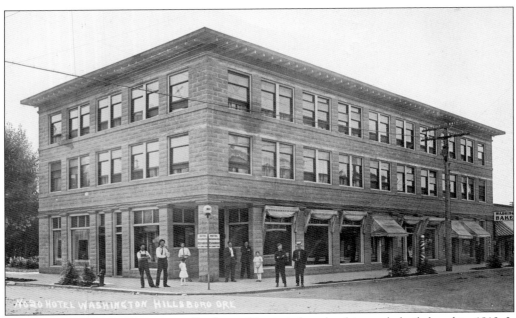

WASHINGTON HOTEL, HILLSBORO. Dr. James Tamiesie bought this newly built hotel in 1910. It was located on the corner of Third and Main Streets. It was torn down in 1956. Dr. Tamiesie also owned a milk condensing plant in Hillsboro (see page 60). (AJS.)

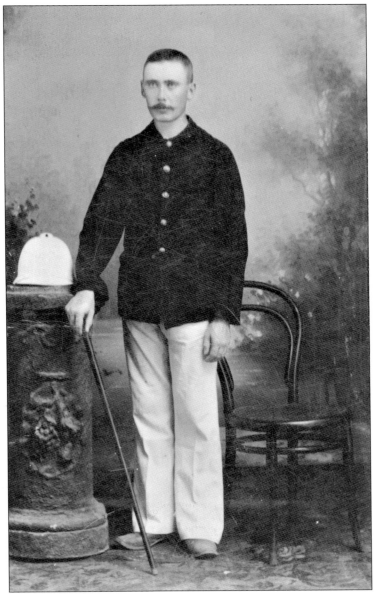

CHARLES PERCY OLIVER, HILLSBORO. Charles Percy Oliver is seen dressed in his Army uniform. Born in Lakeland, Minnesota, around 1858, Oliver left Minnesota as a young man and moved to Portland. He left Portland after a year and moved to Hillsboro. He became a pharmacist, licensed by the state of Oregon, and started working for Dr. Samuel Linklater of Hillsboro. Upon the breakout of the Spanish-American War, Oliver enlisted in Company H of the 2nd Oregon. Dr. Linklater told him not to volunteer and that he would help pay for Charles to continue his medical studies, leading to Charles becoming a doctor. Charles felt it was his duty, and enlisted anyway. He died in Manila, Philippines, on November 2, 1898. Charles Oliver was a popular Hillsboro resident with nearly 500 people attending his memorial services at the Hillsboro Congregational Church on Sunday, November 13, 1898. Not all the people wishing to pay their respects were able to fit inside the church that day. (WCM, 988.)

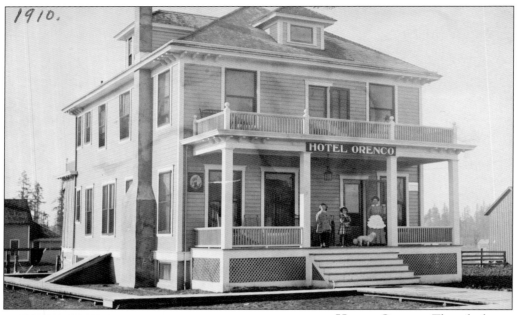

1910.

HOTEL, ORENCO. Though the town of Orenco had a small population, as a company town, it needed a good hotel to provide room and board for the many visitors coming to do business at the Oregon Nursery Company headquartered there. (WCM, 882.)

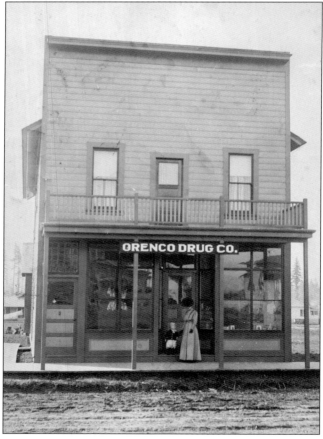

DRUGSTORE, ORENCO. The Orenco Drug Company building was built around 1910 by Dr. William Cunningham. It was located on the original main street of Orenco, which ran parallel to the Oregon Electric Railroad tracks. Dr. Cunningham practiced medicine on the second floor, which was where he also lived. A sickly man, he moved to Sierra Madre, California, and died in 1914 at the age of 38. (WCM, 994.)

DEMOCRAT, HILLSBORO. This is the exterior of the office of the *Washington County Democrat* newspaper, located on Second Street near Wiley's Saloon. The paper was established in 1869 and moved to Forest Grove in the early 1890s. From left to right are Anna Beagle Richardson, John Beagle, editor E.H. Flagg, and Jack Hughes. (WCM, 674.)

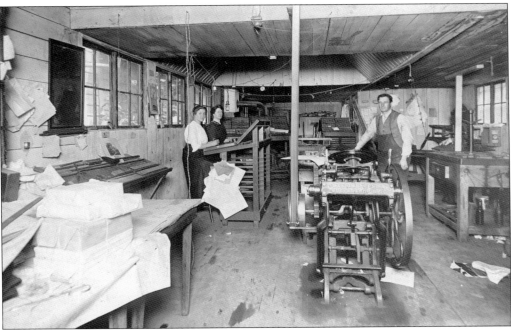

THE *HILLSBORO ARGUS*, HILLSBORO. The interior of the *Hillsboro Argus* newspaper shop is seen here. The *Argus* came to occupy the *Washington County Democrat's* office space. From left to right are Pearl Smith Borgen, copublisher Emma McKinney, and Carl Bunsen. The *Argus* was the job printer responsible for printing the Washington County scrip, seen on page 109. (WCM, 1,001.)

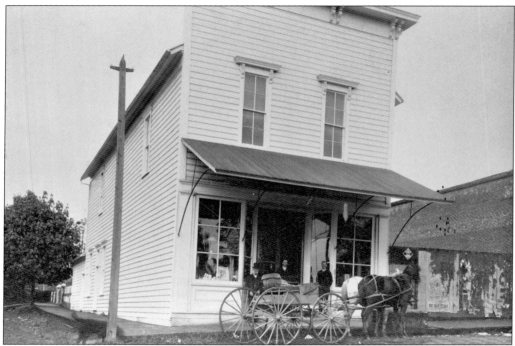

BOWLBY'S PHARMACY, FOREST GROVE. This c. 1886 photograph shows Dr. Wilson Bowlby (left) standing outside his drugstore, located across from Pacific University's campus in Forest Grove. (WCM, 11,097.)

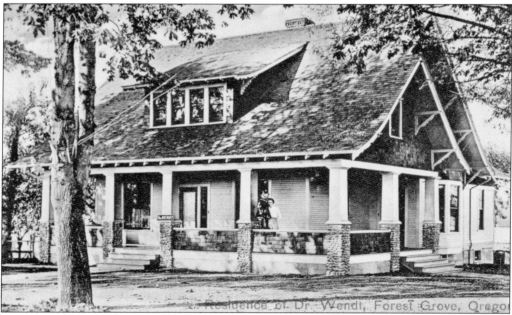

DR. WENDT, FOREST GROVE. This is Dr. Samuel Wendt's combined residence and doctor's office. A small sign with his name on it can be seen on the stairs to the left. Dr. Wendt was a general practice physician. (AJS.)

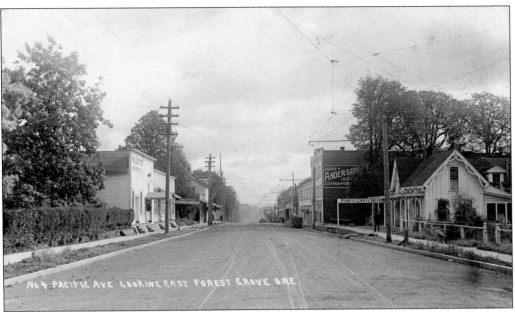

PACIFIC AVENUE, FOREST GROVE. Looking east down Pacific Avenue, the Forest Grove Hotel can be seen on the right. (AJS.)

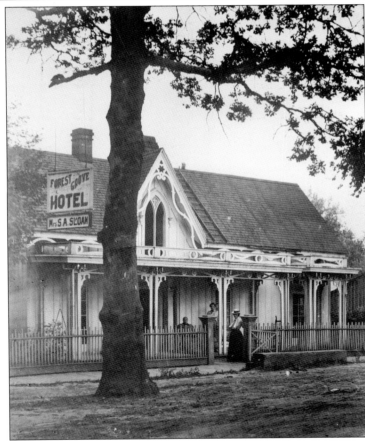

FOREST GROVE HOTEL. A close-up of the Forest Grove Hotel, located on Pacific Avenue, is pictured here. The hotel was also known as Mrs. Sloan's (Mother Sloan) hotel. (WCM, 1,128.)

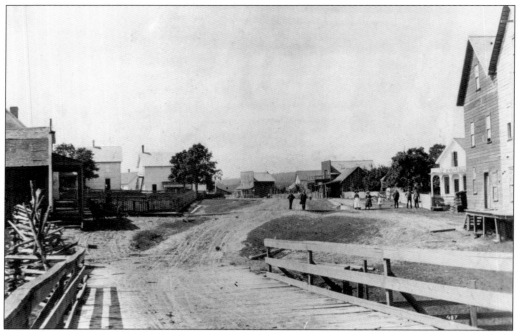

MAIN STREET, GLENCOE. Glencoe was a small community with its own business district lining the main street through the center of town. The town faded away when the railroad came through the area and people and businesses moved to North Plains, which was newly built adjacent to the railroad tracks. Glencoe Road still runs through the area. (WCM, 668.)

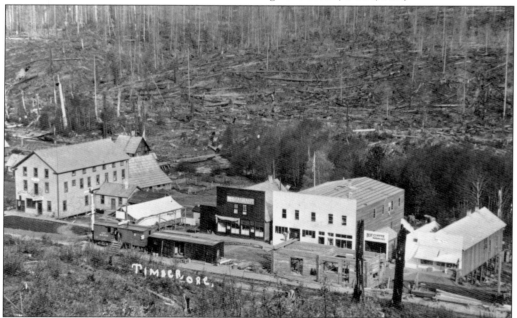

MAIN STREET, TIMBER. This bird's-eye view of the small logging town of Timber shows its few businesses, facing the railroad tracks. The new train depot can be seen being constructed out of logs at the bottom of the image; it was completed in 1915 (see page 32). (WCM, 2,870.)

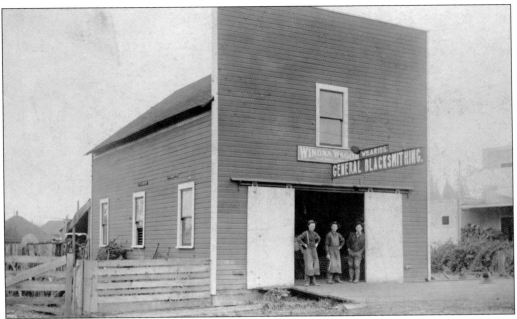

BLACKSMITH SHOP, TIGARD. William Ariss built a blacksmith shop on Main Street in 1912 that eventually evolved into a modern service station. As a side note, 1911 marked the introduction of electricity to the growing community of Tigard, as the Tualatin Valley Electric Company joined Tigard to a service grid with Sherwood and Tualatin. (WCM, 2,862.)

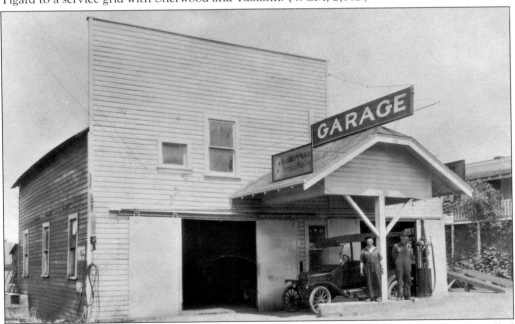

AUTOMOBILE SERVICE STATION, TIGARD. The William Ariss blacksmith shop has a newly installed covered service area added right onto the front of the old blacksmith shop. A large sign proclaims that this business is a garage, and the car parked in front confirms that the blacksmithing job is evolving into one of automobile service and repair. (WCM, 2,861.)

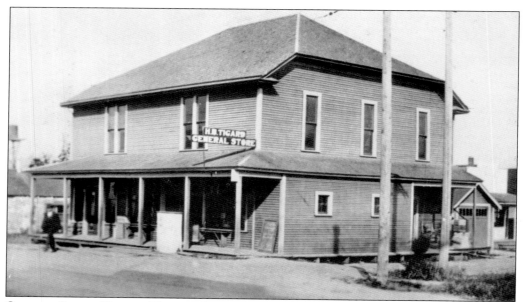

GENERAL STORE, TIGARD. This was the general store in Tigard. The sign on the building reads "H.B. Tigard;" around 1900, Hugh Butler Tigard had the building erected across the street from the Tigard City Hall. (WCM, 2,880.)

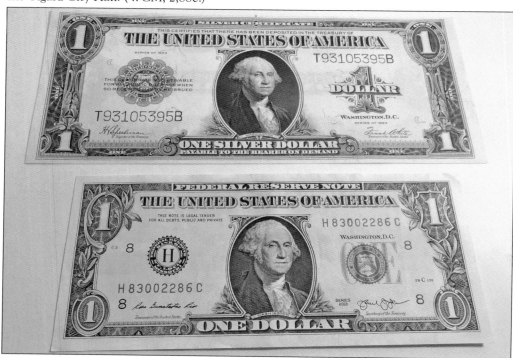

PAPER MONEY, WASHINGTON COUNTY. Most stores featured in this book conducted business on a cash-only basis. This image shows a vintage large dollar bill and a modern dollar bill for comparison. All denominations of US bills were of the large size until 1929, when the Bureau of Engraving and Printing switched to the current size as a means to reduce production costs. (AJS.)

Five

BIG BUSINESS

The rich soil and the abundance of reliable sources of water made the Tualatin Valley perfect for all kinds of crops. One of the nation's largest plant nurseries in the early 20th century was centered in Orenco. The abundant local herds of cows supplied the raw milk for numerous condensed milk factories. Washington County–grown hops were sought after by brewers across the nation. Berries and vegetables were canned for shipment. The forested hillsides to the west and east of the valley proper saw both small- and large-scale logging operations. Later in the 20th century, technology companies moved into Washington County creating what is known as the Silicon Forest. Nike and Columbia Sportswear are also located in Washington County.

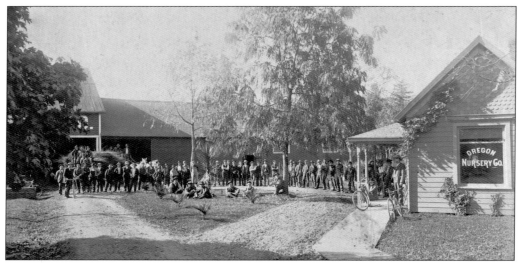

THE NURSERY, ORENCO. Orenco was a company town built by the owners of the Oregon Nursery Company. The name comes from first letters of Oregon Nursery Company. The company had hundreds of acres of nursery products and employed scores of men, as seen here. Many of the workers were recruited directly from Hungary. (WCM, 11,380.)

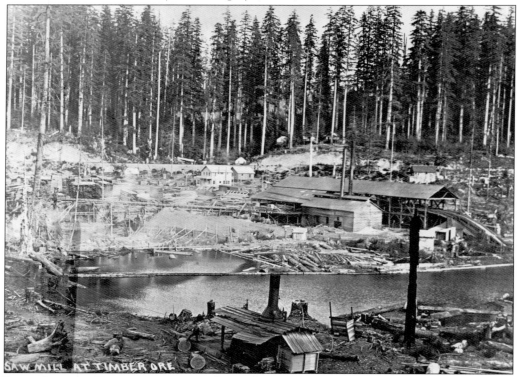

LOCAL SAWMILL, TIMBER. At one time, the small community of Timber had its own sawmill. The large operation is evident in this image. Timber's location on the Southern Pacific Railroad's branch line meant that shipping of finished products from the sawmill was relatively easy. (WCM, 1,727.)

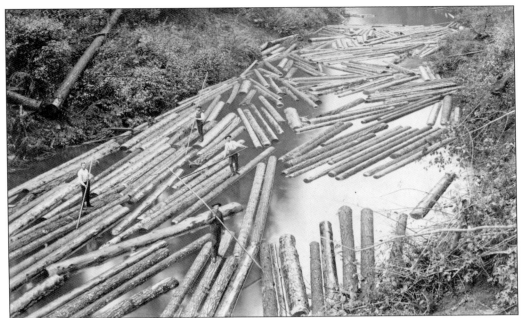

LUMBER COMPANY, HILLSBORO. The Hillsboro Lumbering Company employed men to keep the floating logs moving down the Tualatin River to a sawmill. Constant vigilance was required to prevent a logjam. Joseph Coulson Hare (see page 71) was the proprietor of the lumber company. (WCM, 2,914.)

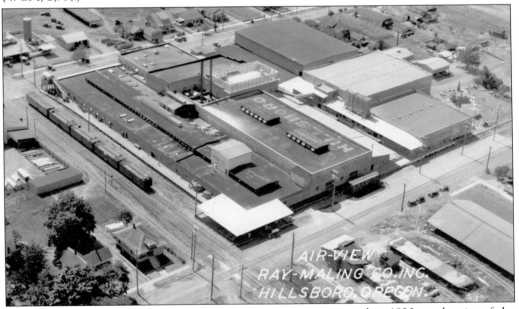

CANNERY, HILLSBORO. The Ray-Maling Cannery was constructed in 1920 on the site of the present-day Washington County Jail. It was downtown Hillsboro's largest employer for many years. The cannery was purchased by the Birdseye Company in 1943, and eventually closed in 1975. Some reports indicate that the flash freezing process for vegetables was invented here. (WCM, 28,082.)

CONDENSER PLANT, HILLSBORO. Dr. James Tamiesie built this milk condensing plant in 1902. Condensed milk was popular because it did not require refrigeration, and if left unopened, had a long shelf life. Condensed milk had a boom time after the Civil War. It had been distributed to Union soldiers, and they brought word of the product back to their hometowns. (WCM, 065.)

RAW MILK DELIVERY, HILLSBORO. A wagon load of milk is ready to unload at the Tamiesie condenser plant. Condenser plants were being built all across the nation in the early part of the 20th century and resulted in a glut of condensed milk being manufactured, causing many small manufacturers to get out of the business around 1912. (WCM, 064.)

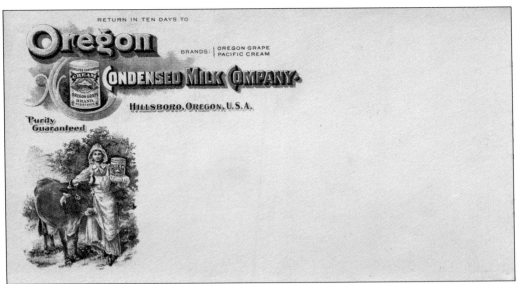

CONDENSED MILK COMPANY, HILLSBORO. This is an unused envelope from James Tamiesie's condensed milk plant on First Street. The company was purchased by Pacific Coast Condensed Milk Co. in 1907. Pacific Coast later became the Carnation Company. The condenser plant in downtown Hillsboro was eventually converted to a pet food factory. (AJS.)

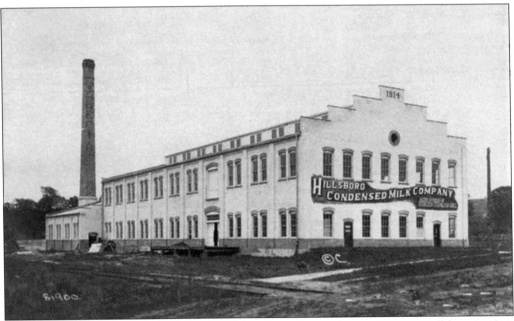

ANOTHER CONDENSER PLANT, HILLSBORO. This milk condenser plant was built in Hillsboro in 1914, as shown by the large date at the top of the building's front facade. An article in the March 25, 1915, *Hillsboro Argus* reports that owners of the new plant expected to soon start operations. (AJS.)

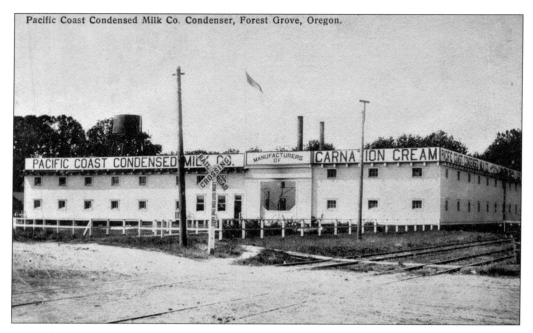

Pacific Coast Condensed Milk Co. Condenser, Forest Grove, Oregon.

CARNATION PLANT, SOUTH FOREST GROVE. This postcard mailed in 1911 shows the Carnation milk condenser plant, built in the community called South Forest Grove. After the Carnation facility had been operating in South Forest Grove for a while, the name of the community was changed to Carnation. The milk plant building burned down in 1929. A new building was erected on the site and served as home to the Carnation Lumber Company. The back of the postcard shows the postmark of South Forest Grove next to the stamp, and the cancellation mark confirming that South Forest Grove was still the name of the community in 1911. (Both, AJS.)

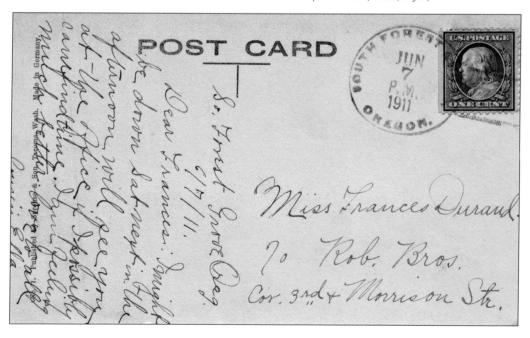

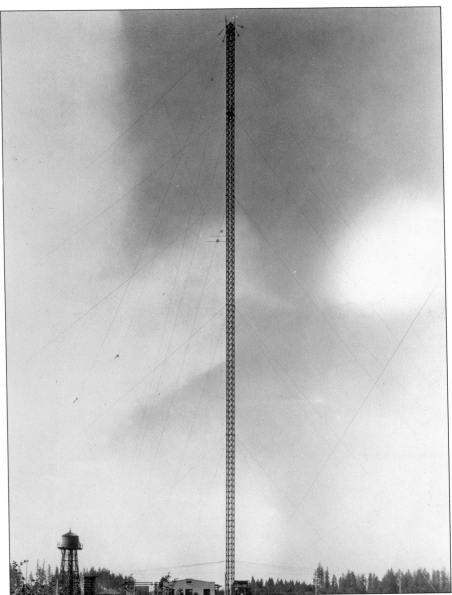

WIRELESS TELEGRAPH TRANSMISSION TOWER, HILLSBORO. In 1921, the Federal Telegraph Company had this transmission tower built just three miles south of Hillsboro. The dedication of the telegraph station with the call letters KGH took place on May 11, 1921. At that time, it was the second tallest steel tower in the world after the Eiffel Tower in Paris, France. The 626-foot-tall tower sat on a concrete base dug 14 feet deep into the ground. The numerous guy wires supporting the tower were 1 ¼ inches in diameter. Some idea of the height of the tower can be judged by the water tower and one-story building at the bottom of the image. The transmissions from this tower were capable of reaching Asia and Europe. During World War II, the federal government took over the operations of the telegraph station and tower. It was then operated by the US Coast Guard and used to contact ships at sea. In 1951, the station was abandoned, and the tower itself was torn down in 1952. (WCM, 1,260.)

JONES HOSPITAL, HILLSBORO. This was the second iteration of the Jones Hospital in Hillsboro. It was located on Seventh Street, between Baseline and Oak Streets. It had 18 beds and was used from the 1920s to the 1950s. Jones Hospital eventually became present-day Tuality Community Hospital. Minnie Jones Coy, the founder, died in 1952. (WCM, 20,168.)

TUALITY HOSPITAL, HILLSBORO. The Jones Hospital was purchased in 1954 by a nonprofit community group and was renamed the Tuality Community Hospital. The building pictured here had 74 beds, two delivery rooms, surgeries, and a laboratory. (WCM, 12,423.)

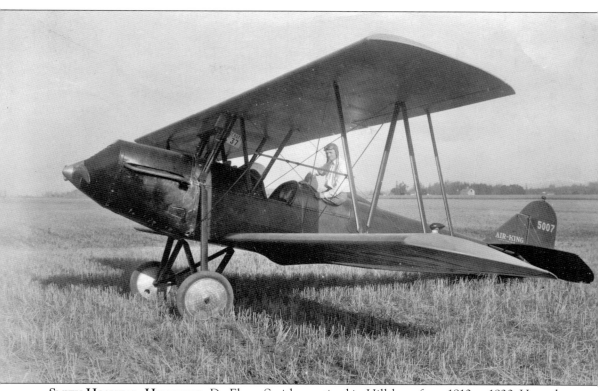

SMITH HOSPITAL, HILLSBORO. Dr. Elmer Smith practiced in Hillsboro from 1910 to 1930. He and a few associates founded a small hospital located above the First National Bank in downtown Hillsboro. Advertisements in local papers listed him as "E.H. Smith, MD, DC, physician and surgeon, osteopath." His father and two brothers were also doctors. Elmer Smith was the first person in Washington County to own an airplane. His plane is shown here. He eventually bought 100 acres of land on the eastern outskirts of Hillsboro to use as his personal airport. He died in June 1930. Before dying, he and his associates acquired the Imbrie residence at Ninth and Washington Streets, which was remodeled for use as a hospital. After Dr. Smith died in 1930, the city purchased his airport land for $7,500 and received a federal grant to significantly improve it by building two runways. This land evolved into the Hillsboro Airport, which now has three runways and is Oregon's second busiest airport. (WCM, 021.)

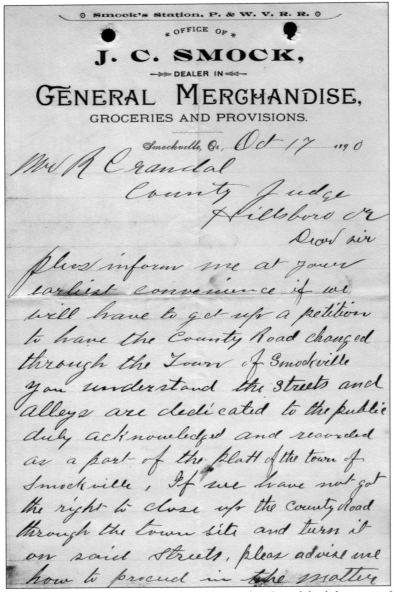

Smock's Station, P. & W. V. R. R.

OFFICE OF

J. C. SMOCK,

→ DEALER IN ←

GENERAL MERCHANDISE,

GROCERIES AND PROVISIONS.

Smockville, Or., Oct 17 1890

Mr R Crandal
County Judge
Hillsboro Or

Dear sir

pleas inform me at your earliest convenience if we will have to get up a petition to have the County Road changed through the Town of Smockville You understand the streets and alleys are dedicated to the public duly acknowledged and recorded as a part of the platt of the town of Smockville, If we have not got the right to close up the County Road through the town site and turn it on said streets, pleas advise me how to proceed in the matter

SHERWOOD, ALSO KNOWN AS SMOCKVILLE. James Christopher Smock had the town of Smockville named after him. This is the first page of a two-page letter on the letterhead of J.C. Smock's general merchandise store. The letter is dated 1890 and is from a time before the name of the community was changed from Smockville to Sherwood. The initials at the top refer to the Portland & Willamette Valley Railway, which was a narrow-gauge railroad. It was bought and sold a few times, and was eventually converted to a standard-gauge operation by a Southern Pacific Railroad subsidiary in 1893. Residents objected to the name of Smockville, and proposed a name change. Robert Alexander, who owned a local brick factory, suggested the name of Sherwood after his hometown of Sherwood, Michigan. James Smock's position and power in the community were not able to overcome people's distaste for the name. Some accounts claim that Smock himself was not that fond of the town's original name. (WCM.)

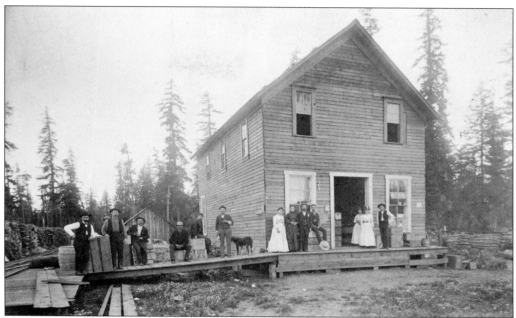

JAMES SMOCK'S EARLY STORE, SHERWOOD. This is James Smock's first store in Smockville with not much surrounding the building. Smock also came to own a threshing machine and a gristmill. He was the largest business owner in town. (WCM, 11,780.)

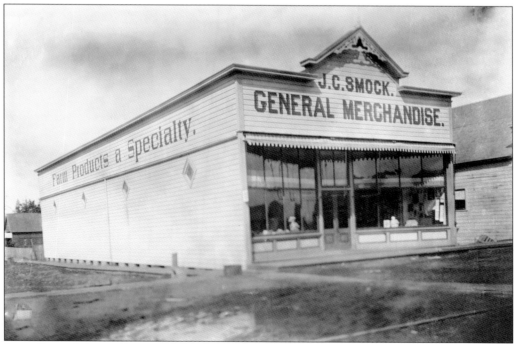

JAMES SMOCK'S LATER STORE, SHERWOOD. This is James Smock's more modern store in the business district of the community, which had grown up around the store. (WCM, 11,781.)

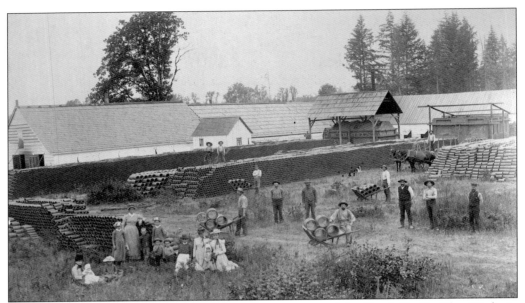

CLAY WORKS, HILLSBORO. James Sewell was the proprietor of the North Pacific Clay Works in Hillsboro. Clay piping became more important as cities installed potable water systems and sewage systems, which both required pipes to move the liquids to and from homes. (WCM, 1,171.)

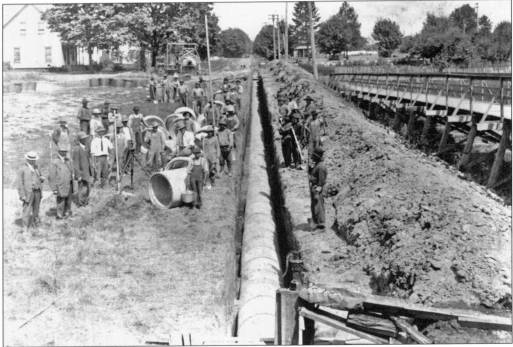

FIRST SEWER SYSTEM, HILLSBORO. This photograph shows workers installing the clay pipes for the first sewer system to be installed in Hillsboro in 1910. Effluent was simply collected in a large tank, which was then discharged directly into the Tualatin River. It was not until the mid-1930s that a sewage treatment plant was built. (WCM, 1,174.)

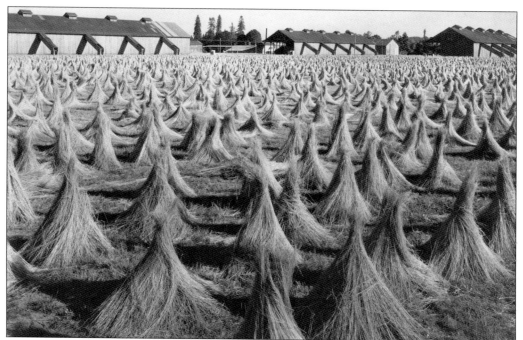

FLAX, CORNELIUS. Flax was a major crop on acreage around Cornelius and at other sites in Washington County. It was the source for linen and linseed oil. The development of synthetic materials like rayon and nylon collapsed the flax market beginning in the 1950s. Stacks of flax were called shocks, and the shape was referred to as teepees or wigwams. (WCM, 12,260.)

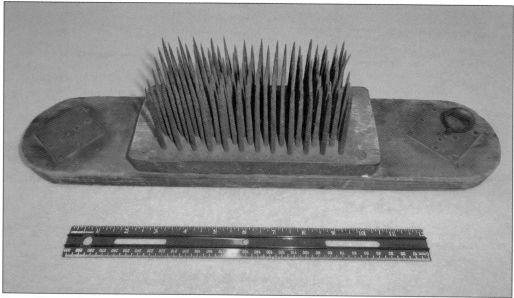

FLAX COMB, CORNELIUS. To separate the flax stalks for further processing, a comb was used. The comb had its own unique name of "hatchel." This photograph shows a hatchel brought to Oregon in 1845 by Lucinda McWilliams, who later married Washington County pioneer David Hill. (WCM, 1972.0114.)

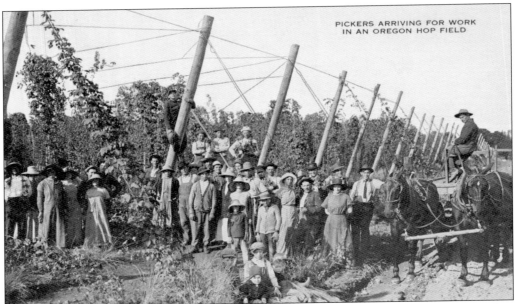

PICKERS ARRIVING FOR WORK
IN AN OREGON HOP FIELD

HOP PICKERS, HILLSBORO. This photograph of hop pickers shows that everyone in the family often got involved. The hop flowers had a rough exterior, and picking was hard on the hands. Pickers would frequently wear gloves for protection. The supporting wires were let down to facilitate the harvesting of the hops. (WCM, 16,767.)

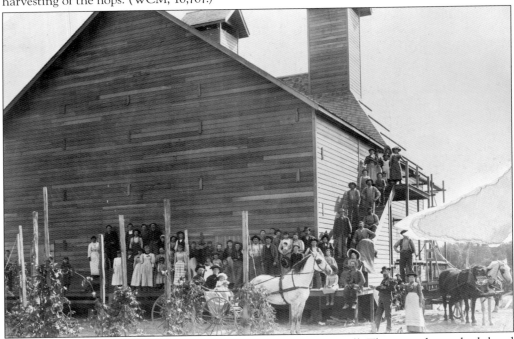

HOP HOUSE, HILLSBORO. A hop house was typically two stories tall. The second story had slated floors covered with burlap. The first floor had a heat source to dry the hops, which were spread out on the burlap on the floor above. Hops grown in Washington County won national quality awards in the early 20th century. (WCM, 057.)

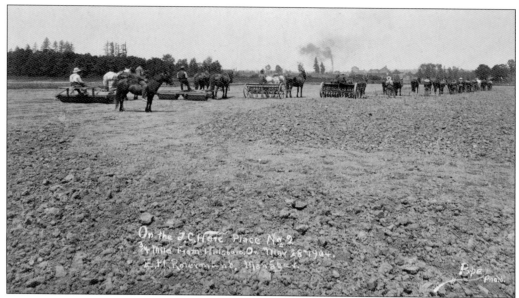

LARGE-SCALE FARMING, HILLSBORO. The ground at Joseph Coulson Hare's Farm No. 2 is being worked by numerous teams of men, animals, and equipment. When this photograph was taken in 1904, this farm was less than a mile outside the city of Hillsboro. (WCM, 099.)

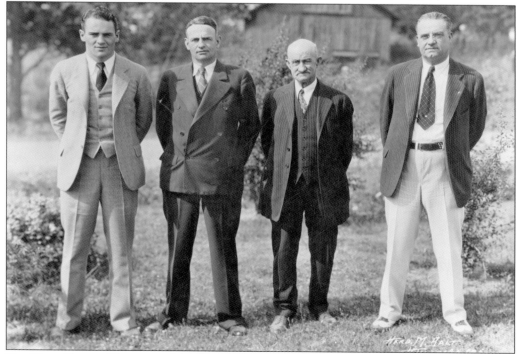

THE HARE FAMILY, HILLSBORO. John Hare (far left) was the son of William Gilman Hare, standing next to him. William G. Hare was a partner in the Hillsboro law firm of Bagley & Hare. William G. Hare's much older brother (19 years), Joseph Coulson Hare, is the short man third from left. Dr. William Bothwell Hare, at far right, was the only son of Joseph Coulson Hare. (WCM, 2,912.)

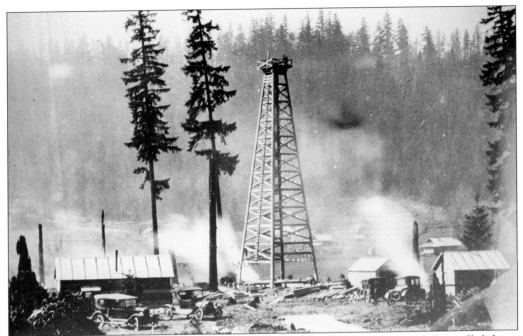

OIL WELL, BUXTON. A test well was dug near the town of Buxton in 1910. The well did not generate a profit. Other test wells were dug in places like Beaverton decades later, but those also failed to produce oil. (WCM, 329.)

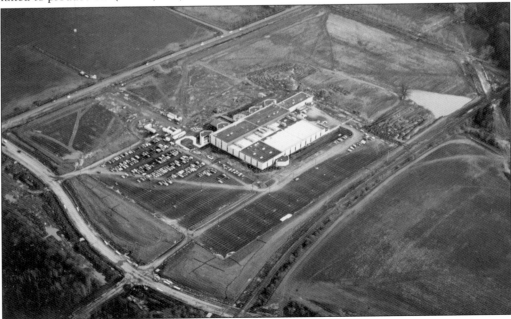

INTEL CAMPUS, HILLSBORO. This aerial photograph taken in 1979 shows the future of Washington County business development. This is the first building going up at Intel's Hawthorne Campus. The Elam Young Parkway is the road at left, and Cornell Road cuts diagonally across the top. (WCM, 18,395.)

Six

SERVICE ORGANIZATIONS AND CHURCHES

The rise of fraternal service organizations grew in the 19th century as another means, besides churches, to provide support to citizens. Famous French historian Alexis de Tocqueville referred to the American reliance on private organizations as early as the 1830s in his *Democracy in America*. The development of modern fraternal orders was especially dynamic in the United States, where the freedom to associate outside governmental regulation is expressly sanctioned in law. There have been hundreds of different fraternal organizations in the United States, and at the beginning of the 20th century, many American men belonged to one or more of them. Such organizations, including the Masons, the International Order of Odd Fellows, and the Modern Woodmen of America, appear in this book. All of these fraternal organizations led to the period being referred to as "the Golden age of fraternalism." Churches not only provided citizens a place of worship, but each congregation also typically provided support to fellow church members. Only a few Washington County churches are shown in this chapter, as there were and are enough for an entire book devoted to just churches. Large-scale federal government aid programs were not instituted until the Great Depression under President Roosevelt's New Deal and later in President Johnson's Great Society.

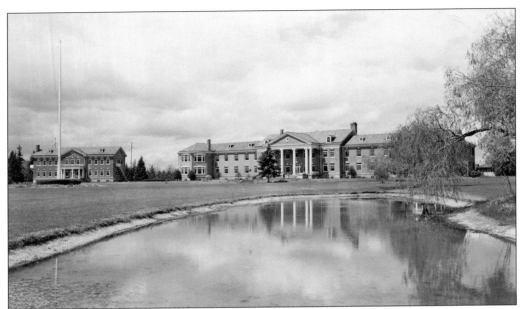

MASONS, FOREST GROVE. The Freemasons are one of the most recognized fraternal orders in the United States and Europe. This photograph shows the Masonic–Eastern Star retirement home on the right and the smaller Children's Cottage on the left. Since 2000, the Masonic building on Pacific Avenue in Forest Grove has housed a McMenamins hotel and restaurant. (WCM, 12,863.)

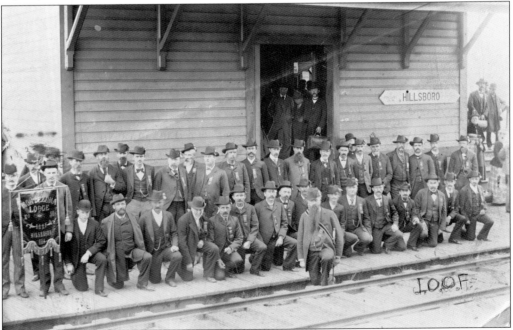

ODD FELLOWS, HILLSBORO. Members of the Montezuma Odd Fellows Lodge No. 50 are awaiting the arrival of a train at the Southern Pacific Railroad station in Hillsboro. The railroad depot shown here was on South First Street. (WCM, 874.)

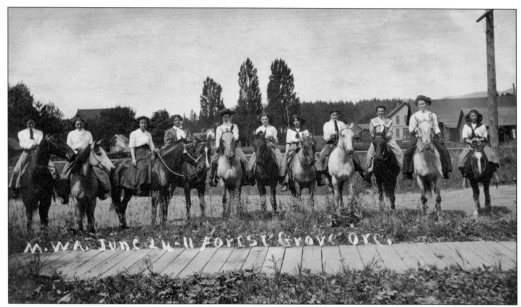

MWA Picnic, Forest Grove. The Modern Woodmen of America (MWA) hosted a large county-wide picnic in Forest Grove on Saturday, June 24, 1911, where this photograph of women on their horses was taken. The Modern Woodmen of America should not be confused with the Woodmen of the World, which was another, similarly named fraternal organization. (AJS.)

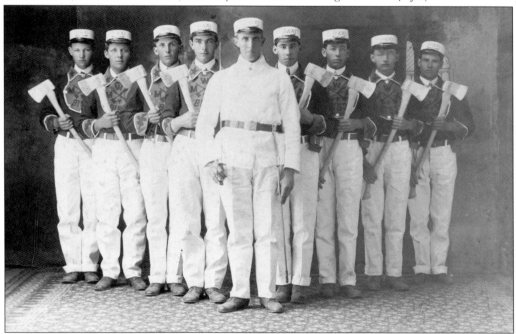

Modern Woodmen of America, Hillsboro. Shown here is a formal portrait of Woodmen in their uniforms holding axes as a symbol of their fraternal organization. The Modern Woodmen of America are still active and are one of largest fraternal benefit societies in the United States, based on assets. (WCM, 16,254.)

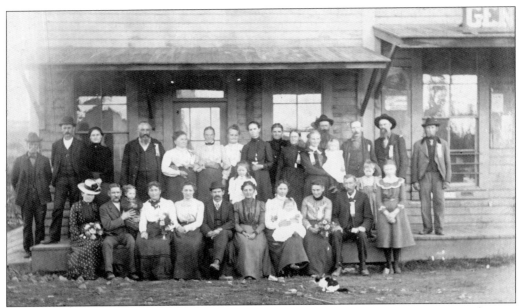

LOCAL GRANGE, SHERWOOD. The Grange is a farmers' association organized in the United States in 1867. It sponsors social activities, community service, and political lobbying. Members typically meet in a building known as a Grange hall. The Grange is still an active organization, with meeting halls sprinkled across Washington County and throughout the United States. (WCM, 11,792.)

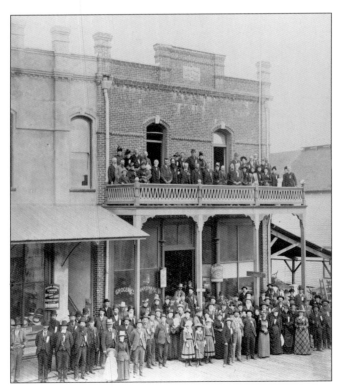

GRANGE, HILLSBORO. The full name of the organization known as the Grange is the National Grange of the Order of Patrons of Husbandry. As its full name implies, the Grange usually drew its members from the local farming and ranching businessmen. This photograph shows an 1891 Grange convention held in Hillsboro on Main Street near Third Street. (WCM, 675.)

KNIGHTS OF PYTHIAS, HILLSBORO. The Hillsboro Knights of Pythias lodge was No. 34, as evidenced by the large sign at the top of the facade. The Knights of Pythias is a nonsectarian fraternal organization intent upon conducting benevolent activities in the local community. (WCM, 14,490.)

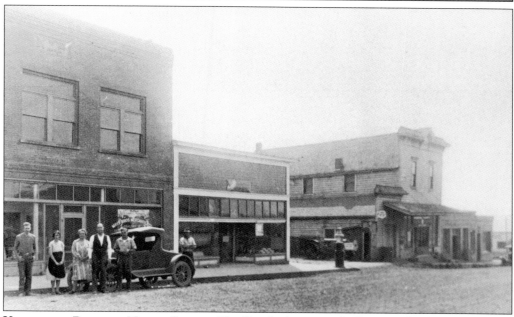

KNIGHTS OF PYTHIAS, NORTH PLAINS. The Knights' meeting hall in North Plains was in the upper story of the first building on the left. As with many fraternal buildings erected in towns, the first floor of the structure was usually occupied by a small business. (WCM, 3,242.)

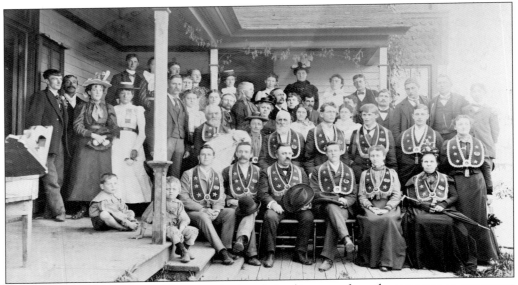

GOOD TEMPLARS, SHERWOOD. This organization derived its name from the temperance movement espousing a life of good works and no alcohol or drugs. This photograph of the Grand Lodge members was taken in Sherwood in 1895. The Order of Good Templars was founded in 1851 and still exists today with headquarters in Stockholm, Sweden. (WCM, 11,763.)

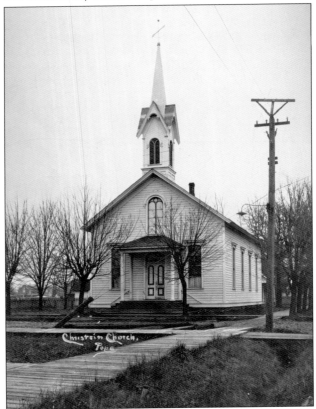

CHRISTIAN CHURCH, HILLSBORO. The church building pictured here was built in the 1880s on Third and Baseline Streets. It was remodeled in 1913 and again in 1929, and was torn down in 1967. A new Christian Church was built on Edison Street. (WCM, 476.)

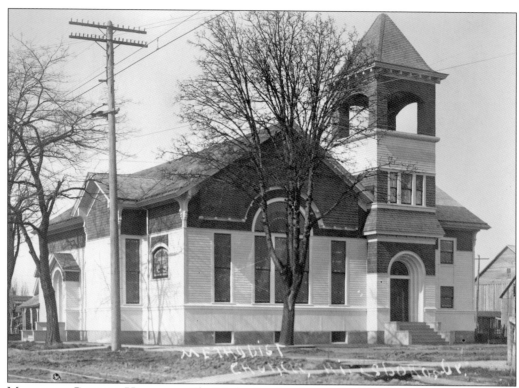

METHODIST CHURCH, HILLSBORO. The Methodist church, seen here in 1910, was on the corner of Third and Washington Streets. As a child and as an adult, Albert Tozier would ring the church bell on New Year's Eve. He became editor of the *Hillsboro Independent*. (WCM, 484.)

METHODIST CHURCH PASTOR, HILLSBORO. This is a portrait of the Hillsboro Methodist Church's pastor C.M. Bryan and his family. Reverend Bryan preached at the Methodist church in the 1880s. This photograph was taken at a professional photography studio. (WCM, 230.)

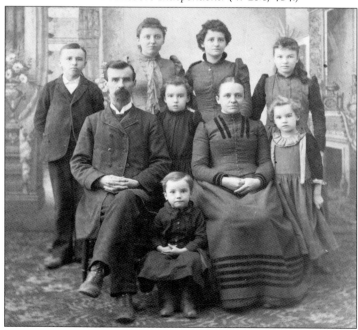

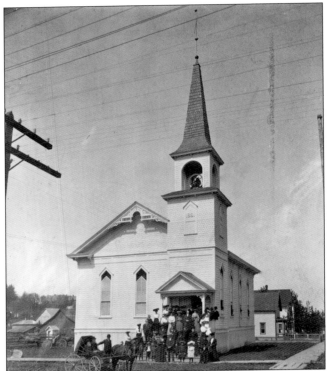

FIRST CHRISTIAN CHURCH, FOREST GROVE. Members of First Christian Church, built in 1891, are pictured standing on the front steps. The church was erected at the corner of Nineteenth and Cedar Streets. The building caught fire in 1946 and burned down. (WCM, 16,215.)

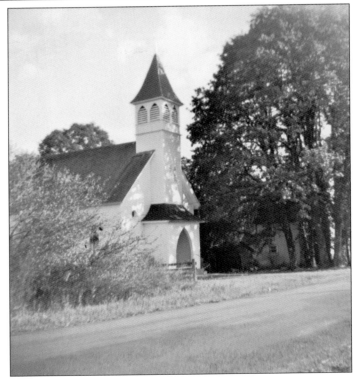

COMMUNITY CHURCH, GALES CREEK. Gales Creek is a small community northwest of Forest Grove. This is a 1966 photograph of the church building. Note how close it sits to the road. The full name of the church was Community Church of God. (WCM, 475.)

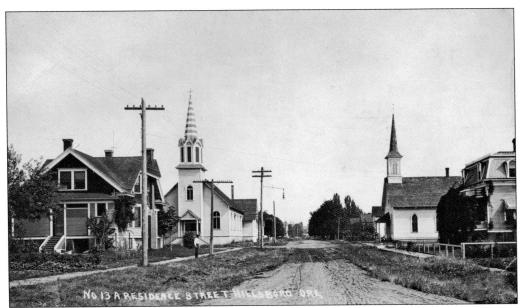

A PAIR OF CHURCHES, HILLSBORO. At the corner of Third and Walnut Streets sat two churches across the street from each other. In this c. 1910 image, St. Matthew's Catholic Church is on the left, and the Hillsboro Baptist Church is on the right. (WCM, 15,419.)

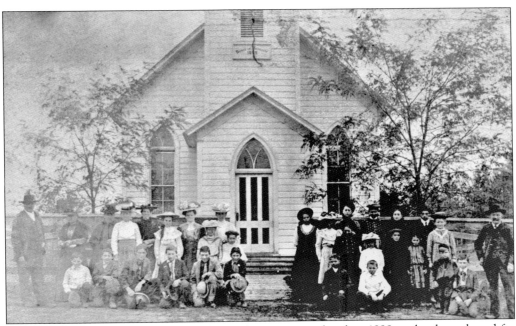

COMMUNITY CHURCH, HELVETIA. This building was completed in 1899 on land purchased for both a church building and a cemetery. Originally called the Reformierte Emmanuels Kirche by the Swiss and German congregation, the community members of Helvetia renamed their church the Community Church when they became independent from their mother church in 1956. (WCM, 19,160.)

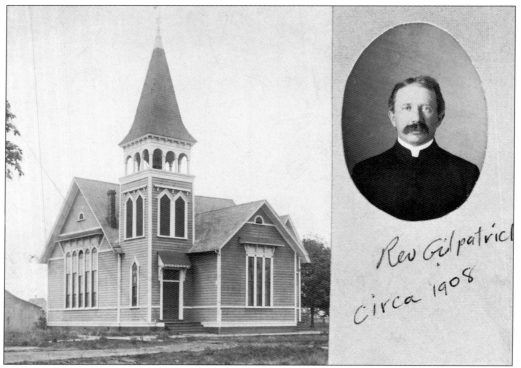

CONGREGATIONAL CHURCH, HILLSBORO. In order to supplement his meager income from preaching, Rev. Howard Gilpatrick took a job as a field boss in a local hop yard. This side job was not viewed favorably by his congregation, as they felt it condoned the production of beer. Gilpatrick was forced to quit his work in the fields. (WCM, 481.)

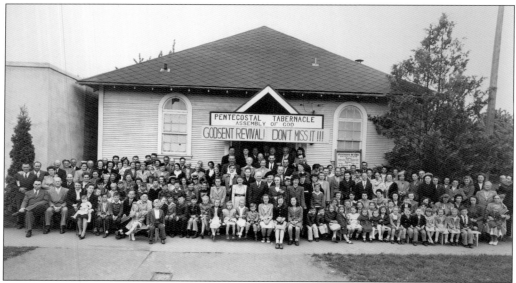

PENTECOSTAL TABERNACLE, HILLSBORO. Pentecostal Tabernacle's congregation has assembled in front of their church in the 1940s. The banner above the front door reads "God-Sent Revival! Don't Miss It!!!" (WCM, 12,387.)

Seven

SPORTS AND
ENTERTAINMENT

Peoples' desire to congregate and share experiences was one factor that would often lead to the formation of sports teams and groups to participate in the performing arts. Even the very smallest of towns in Washington County were able to field a baseball team, needing only nine players. There were usually enough people who wanted to play an instrument that most communities could form a band. There were also events like boxing matches, wrestling matches, horse racing, ice cream socials, plays, and dances. When Main and Second Streets in Hillsboro were planked, the county fair was held right on the planks. Then the fair was held inside the large nursery packing and shipping building at Orenco. From 1925 to 1951, the fair was held at Shute Park. In 1952, the fair moved to its current location across Cornell Road from the Hillsboro Airport.

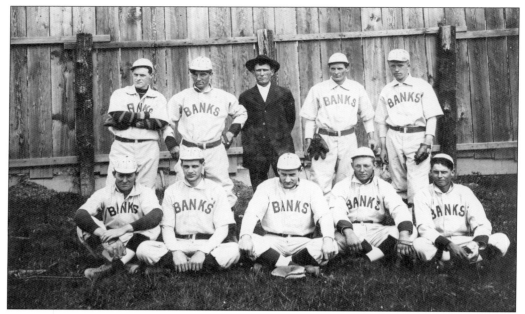

BASEBALL, BANKS. Though the community of Banks had a small population 100 years ago, the town fielded a very strong baseball team. The namesake of the town and manager of the team, Robert Banks, is standing in civilian clothes among his players. (WCM, 031.)

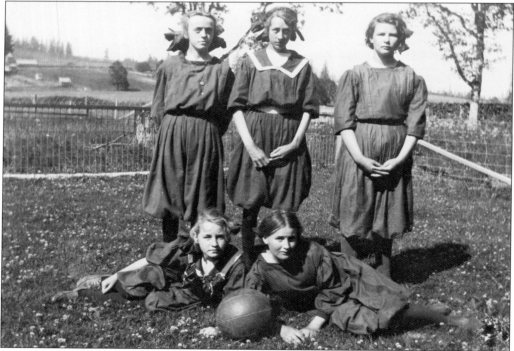

GIRLS' BASKETBALL TEAM, BANKS. This c. 1910 photograph is of the Banks girls' basketball team. From left to right are (first row) Eva Schulmerich and Donna Stafford; (second row) Flonnie Turner, Bessie Roberts, and Eva Carstens. (WCM.)

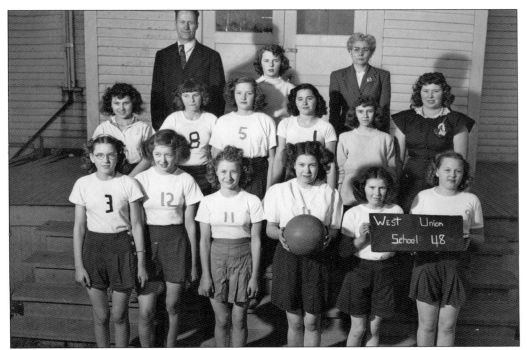

GIRLS' BASKETBALL, WEST UNION. The unincorporated community of West Union had a girls' basketball team. This photograph is from 1948, according to the sign being held by the two girls in the front row on the right. (WCM, 13,064.)

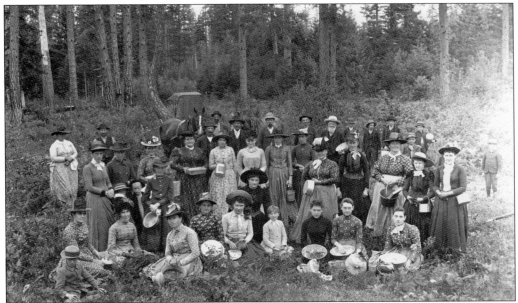

HUCKLEBERRY PICKING FOR HOME CONSUMPTION, HILLSBORO. This c. 1890 photograph shows a large group of men, women, and children in the woods northeast of Hillsboro. Huckleberries are related to blueberries and cranberries. They typically reach their peak of ripeness in August. (WCM, 027.)

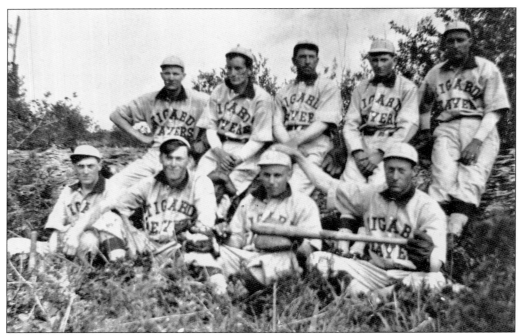

BASEBALL, TIGARD. The Tigard Beavers were a semiprofessional baseball team active from 1912 to 1915. This photograph of the team was taken around 1914 and shows Bill Schamoni holding a bat. (WCM, 11,071.)

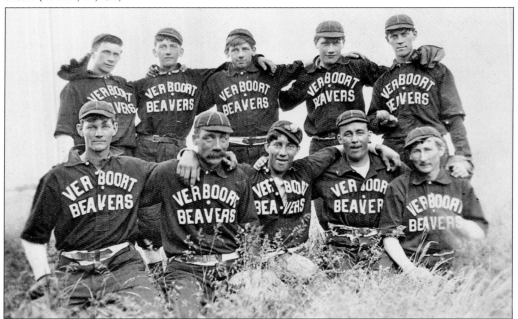

BEAVERS BASEBALL, VERBOORT. Verboort is a small community just outside of Forest Grove. This was their baseball team around 1910. The most famous baseball player from Verboort was Larry Jansen, a New York Giants pitcher in the 1950s. He pitched in the 1951 World Series. Jansen was born, raised, and died in Verboort. (WCM, 18,517.)

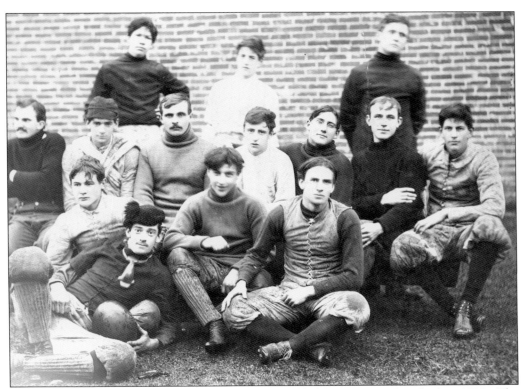

FOOTBALL, HILLSBORO. Members of a Hillsboro football club are pictured in the late 1890s. The game was very violent, with 19 fatalities recorded across the nation in 1905. This photograph was taken before the forward pass was legalized in 1906. Note the large, rugby-style ball, which was not conducive to passing. Edmund Tongue is holding the ball. (WCM, 040.)

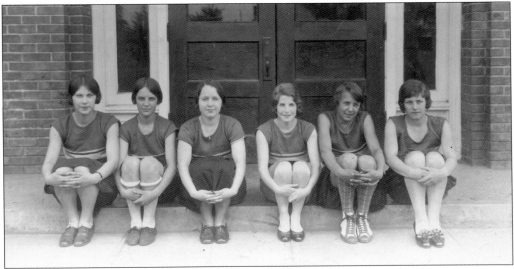

GIRLS' BASKETBALL, HILLSBORO. Basketball was a popular sport for girls to play in the early 20th century. Though many still play basketball today, soccer is gaining in popularity among modern young women. (WCM, 042.)

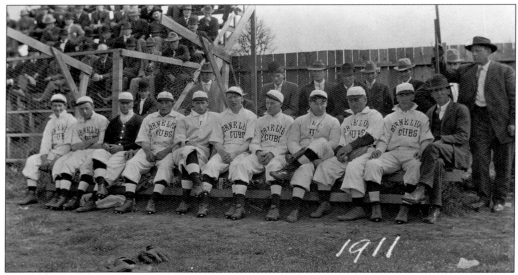

BASEBALL, CORNELIUS. The Cornelius Cubs are posing for this group photograph in 1911. The Cubs won the Washington County pennant in 1911. Like most baseball teams from this era, they often fielded only the minimum number of players. The Cubs are showing 10 players on the bench, which is one more than necessary. (WCM, 034.)

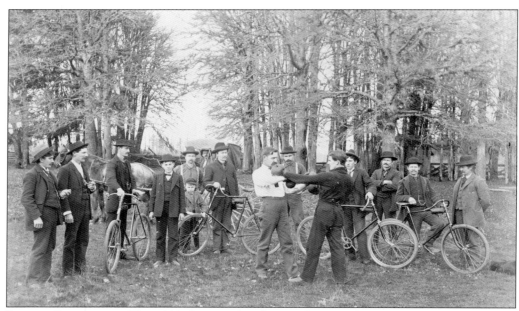

BOXING, FARMINGTON. This 1898 photograph, taken on the grounds of the Farmington Christian Church, was most likely posed. Farmington is about eight miles outside of Beaverton. The two boxers are identified on the original photograph as John Boge and William Jack. (WCM, 694.)

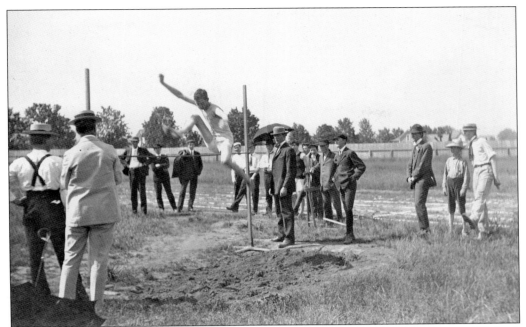

HIGH JUMP, FOREST GROVE. John Weatherred, brother to Lucy Weatherred (see page 28), high jumps at a Pacific University track and field meet. Note that the young man is jumping and landing on the ground at the same grade. There seems to be little attempt made to soften the landing spot. (WCM, 045.)

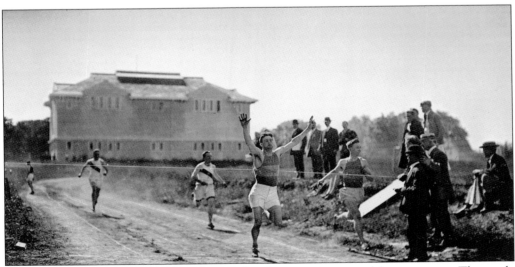

THE WINNER, FOREST GROVE. This footrace has few participants and few spectators. The newly built gymnasium building at Pacific University can be seen in the background. (AJS.)

MOVIE SET, BEAVERTON. Under the leadership of John J. Flemming, a group of businessmen from Portland started a movie production company called Premium Pictures. The group negotiated a deal with the city of Beaverton, and a large movie studio building was built on Erickson Street in 1922. This is a movie set inside that studio. (WCM, 9,986.)

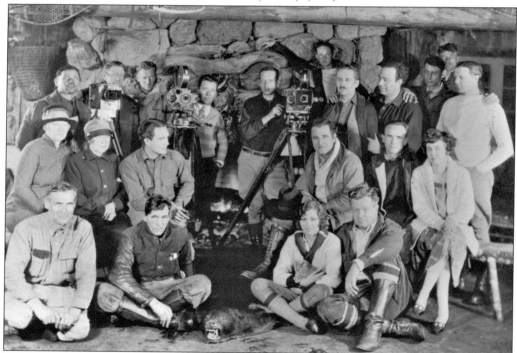

MOVIE CREW, BEAVERTON. Cameramen, actors, and other studio personnel gathered for this photograph. The movie studio in Beaverton was a large building similar to the large studios back East and those being built down in Los Angeles. The film company's Westerns were shot outdoors in Arizona. (WCM, 9,988.)

MOVIE STILL, BEAVERTON. This image is a still from one of the approximately 15 silent films produced by Premium Pictures prior to the company going bankrupt in 1925. Pauline Curley, pictured, was the female lead in *Flames of Passion*. The Beaverton property on which the studio sat became the Watts Airfield. (WCM, 11,703.)

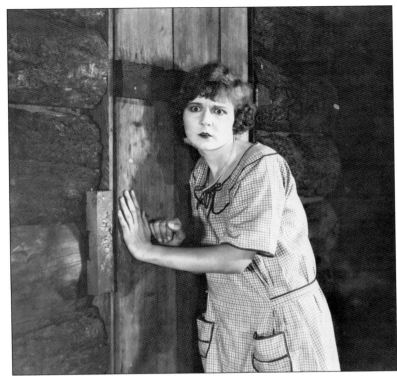

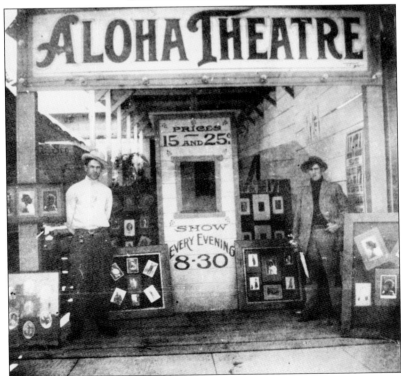

THEATER, ALOHA. In the earliest days of movies, they were usually called moving picture shows and were silent. The larger county towns like Hillsboro, Forest Grove, and Beaverton had movie houses, and even the small town of Aloha had this theater for a short time. (WCM, 10,171.)

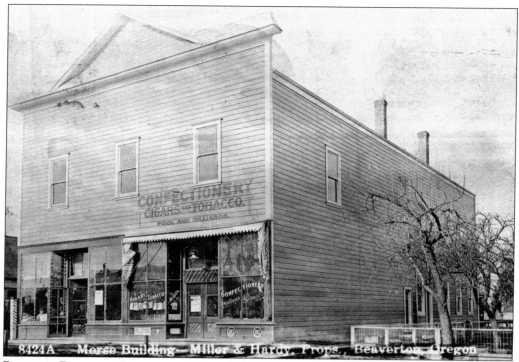

POOL AND BILLIARDS, BEAVERTON. Through the years, pool halls have been labeled as bad places for young men to hang out after school. The Beaverton pool hall was located in the Morse Building, as can be seen by the sign painted on the front of the building just above the windows on the right side. (WCM, 23,573.)

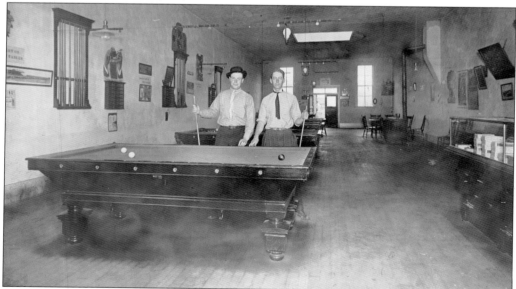

POOL HALL, HILLSBORO. Joseph Williams owned a pool hall inside the Peterson Building. The pool hall had a grill to make meals. On the left is Alfred Morgan, and on the right is Elba "Al" Southers. (WCM, 1,074.)

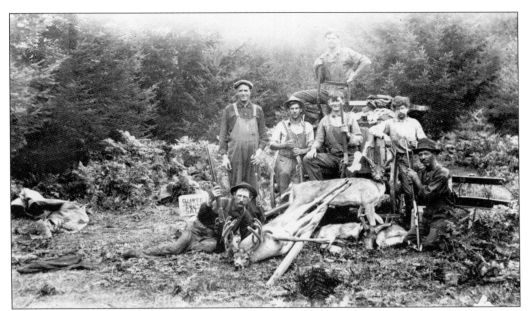

DEER HUNT, FOREST GROVE. Hunting was both a form of entertainment and, if lucky, a source of meat. These hunters are posing with the deer they shot. The box of salt at the left of the group might indicate the hunters used a salt lick to attract the deer to their blind. (WCM, 13,384.)

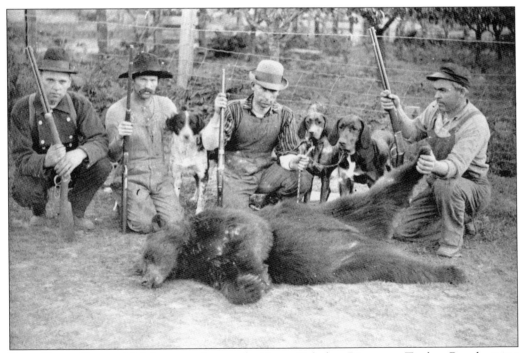

BEAR HUNT, TIMBER. This bear was shot on the Upper Nehalem River near Timber. Bear hunting was popularized by Pres. Theodore Roosevelt, whose exploits provided the origins for the stuffed teddy bear. (WCM, 348.)

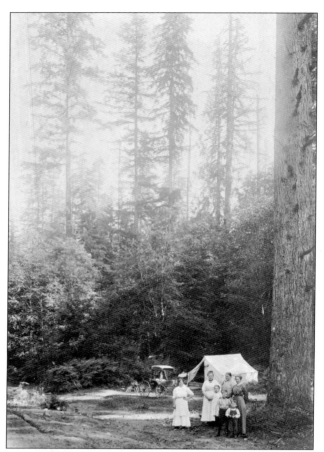

CAMPING, BUXTON. This group is camping among the huge old-growth trees near Buxton. One of the older women is Sydney Samantha Deardorff of Cornelius. Born in Missouri in 1848, she died in 1931 and is buried in the Cornelius Methodist Cemetery. (WCM, 260.)

HORSE FAIR, HILLSBORO. Julian Johnson (see page 112), the photographer of this 1911 image, has labeled the event a "horse fair." A couple of decades earlier, these events were typically called a "stallion parade." (WCM, 879.)

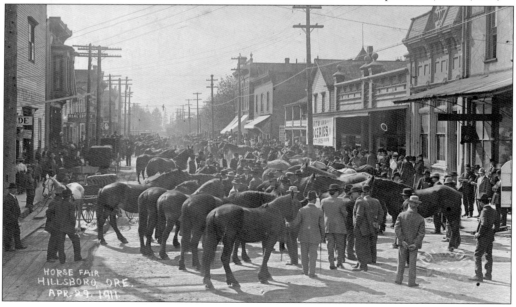

CHILDREN'S PARADE, HILLSBORO.
As part of the July 4, 1915,
holiday weekend, the following
events were scheduled: a
children's parade on Saturday,
July 3; a Sunday school parade on
Sunday, July 4; and a civic parade
on Monday, July 5. Prizes were
to be awarded at the children's
parade for best decorated doll
buggies, little wagons, and baby
buggies. Children under 15
were invited to participate from
all over the county. (AJS.)

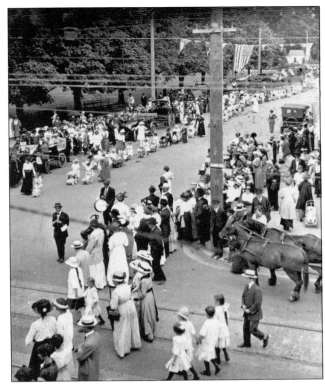

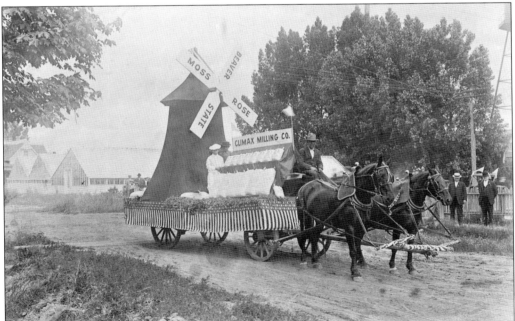

CLIMAX MILL'S FLOAT, HILLSBORO. The Climax flour mill built this float for a Fourth of July parade in 1910. The vanes of the windmill advertise the flour brands milled at the Climax Mill. An image of the Climax Mill can be seen on page 48. (WCM, 621.)

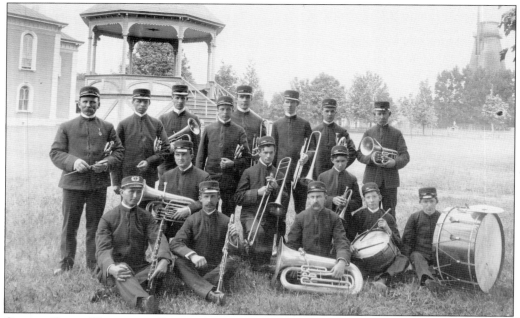

CORNET BAND, HILLSBORO. On June 28, 1904, members of the Hillsboro reed and cornet band are seen on the grounds of the Washington County Courthouse, which is the two-story brick building at far left. The tall tower in the background at far right is the city water tower, which can be seen on page 42. (WCM, 28,092.)

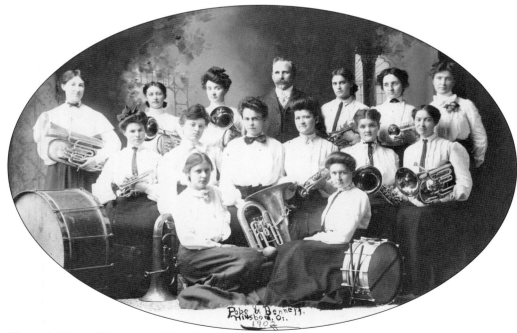

WOMEN'S BAND, HILLSBORO. The photography studio of Pope & Bennett in Hillsboro took this image of the women's band in 1902. William Wall was its bandleader; in the 1900 US Census, he is listed as a stenographer. (WCM, 148.)

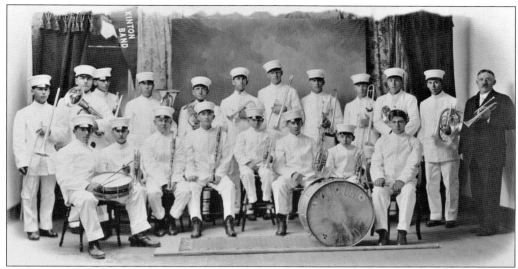

BAND, KINTON. In 1912, the small community of Kinton was able to muster enough musicians to form a marching band, pictured here. (WCM, 16,578.)

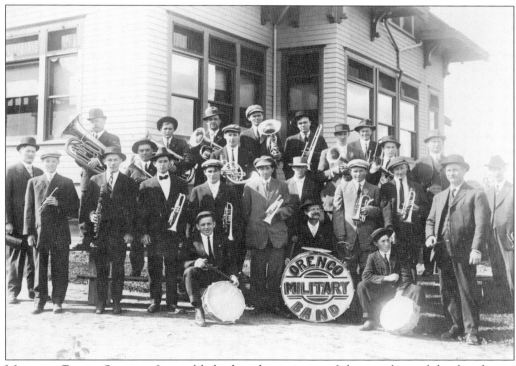

MILITARY BAND, ORENCO. It was likely that the majority of the members of this band were employees of the Oregon Nursery Company. "Military band" was the name given to a civilian band comprised of brass, woodwind, and percussion instruments usually played during a march or parade. (WCM, 150.)

MAKE A BET, FOREST GROVE. Charles Fritz made a wager with Joseph Vaughan, both of Forest Grove. Fritz, who owned a photography studio in town, bet Vaughan that Grover Cleveland would not win the presidential race against Benjamin Harrison in 1892. Cleveland won the election, and Fritz, as the loser, had to wheel Vaughan twice around Congregational Square. The image above shows Vaughan riding high in a wheelbarrow waving the Stars and Stripes. Below, Fritz has spilled Vaughan into the muddy street. (Above, WCM, 615; below, WCM, 614.)

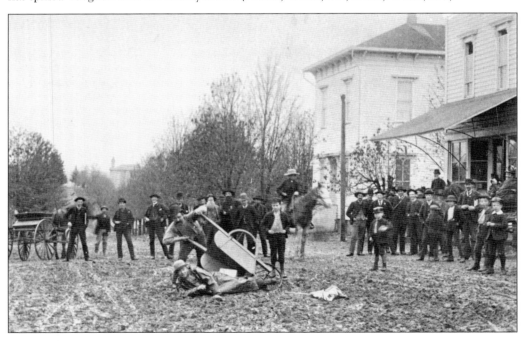

Eight

SCHOOLS AND GOVERNMENT

Since funding for school districts was a county government function, schools are included in this chapter with government topics. At the beginning of the 20th century, Washington County had over 100 grammar schools and 10 high schools. There were also private schools, such as Pacific University, and religious schools. Other typical governmental functions, such as law enforcement and the court system, are represented here, along with a few of Washington County's lawbreakers. Some photographs of post office buildings are in this chapter too. Back before the development of the telephone system, letters and postcards were the primary means of communication among people and businesses. Establishing a post office in a community would often determine the official spelling of the town's name.

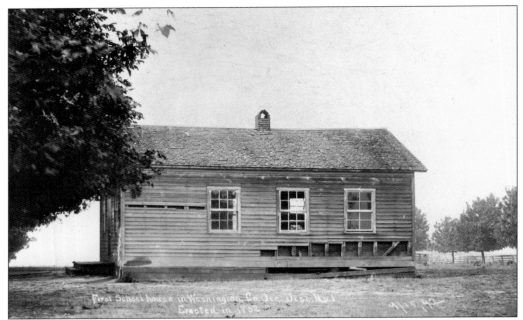

FIRST SCHOOL, WEST UNION. This is the first schoolhouse in Washington County. It was erected in 1852 with William Geiger serving as the teacher. The school was built in School District No. 1, which was organized in 1851. Prior to the construction of this dedicated school building, classes were held in people's homes or in churches. (WCM, 1,453.)

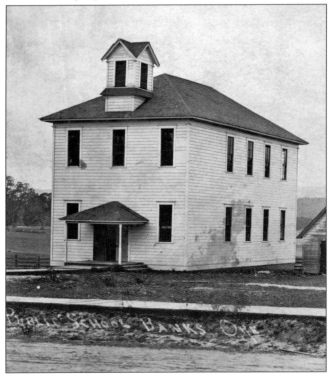

EARLY PUBLIC SCHOOL BUILDING, BANKS. Banks had this two-story school building, as shown on a postcard view from around 1910, which was early in the town's development. The community of Banks started to grow in 1901 with news of the railroad coming through the area. (WCM, 2,869.)

LATER PUBLIC SCHOOL BUILDING, BANKS. This is a later version of the public school building in Banks. (WCM.)

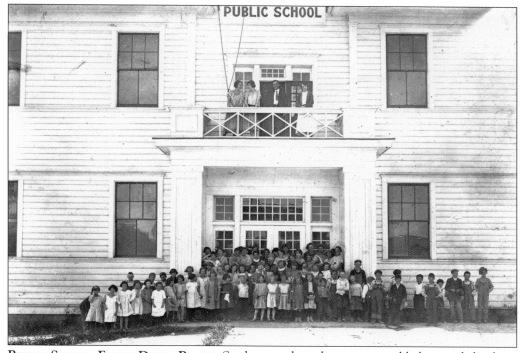

PUBLIC SCHOOL FRONT DOOR, BANKS. Students and teachers are assembled around the front door to the Banks public school. (AJS.)

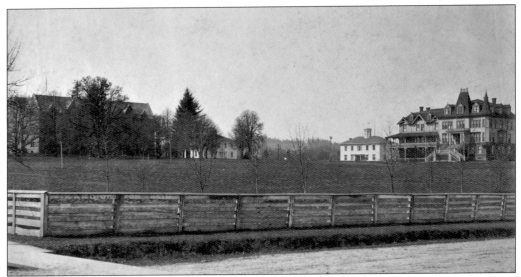

Pacific University Grounds, Forest Grove. The school's main campus has had a variety of different buildings over its 150-year history. At far right is the first Herrick Hall, which was an all-female residence. It burned down in 1906. The white building adjacent to Herrick Hall is the Old College Hall, constructed in 1850 and moved around on campus three times. The Old College Hall now serves as a museum open to the public. (WCM, 23,387.)

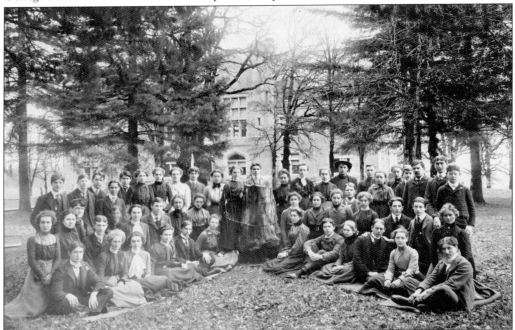

Pacific University Students, Forest Grove. The coeducational nature of Pacific University can be seen in this class photograph of roughly a 50-50 mix of men and women students. The students are grouped on either side of the petrified stump erected on this site by the class of 1867. The stump identifies the location of the original log school, Tualatin Academy, built by Harvey Clark. The academy evolved into Pacific University. (WCM, 12,155.)

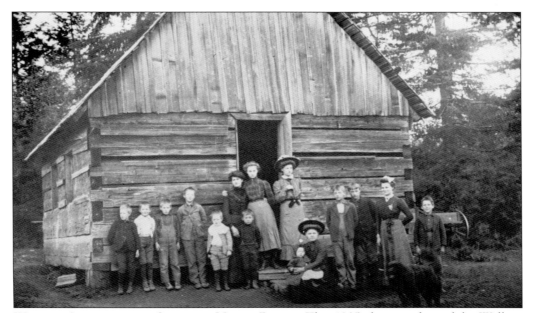

WALLACE SCHOOL BEFORE SHINGLES, NORTH PLAINS. This 1905 photograph is of the Wallace School, built in the 1880s. Lillian Nelson is holding baby Myrtelle Nelson. At the time, Jennie Brooks was the teacher. (WCM, 3,249.)

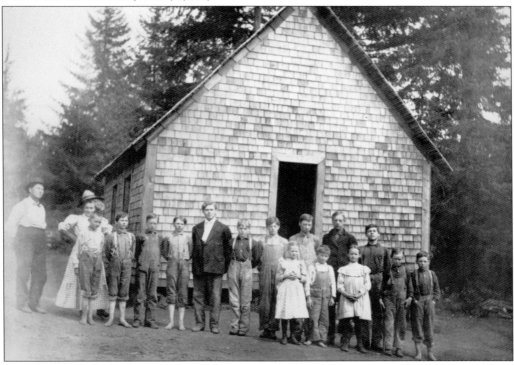

WALLACE SCHOOL AFTER SHINGLES, NORTH PLAINS. Shingles have been added to the Wallace School. A larger school was built later, but by the 1961–1962 school year, the Wallace School was closed, and the students started going to the Shadybrook School. (WCM, 3,250.)

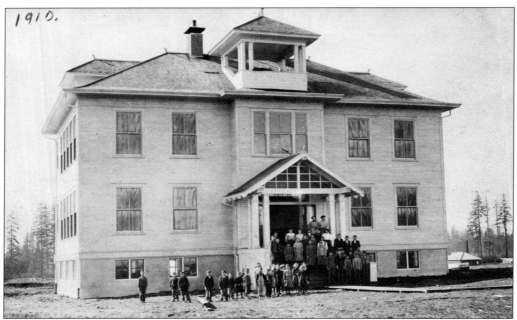

PUBLIC SCHOOL, ORENCO. Students and teachers are posing for this 1910 photograph. Imagine the language barrier encountered between teacher and students when many Hungarian families were recruited to come and work at the Oregon Nursery Company. (WCM, 1,228.)

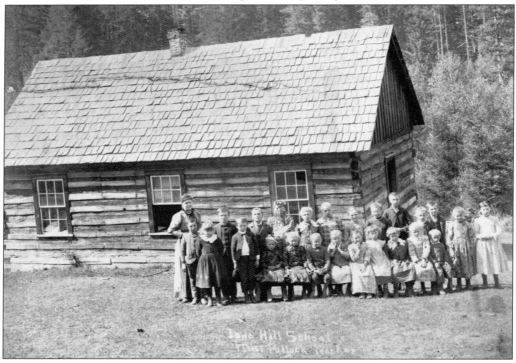

ONE-ROOM SCHOOL, IOWA HILL. The Iowa Hill School District was located northeast of Gaston. The teacher in this photograph is Flora Pollock. (WCM, 1,308.)

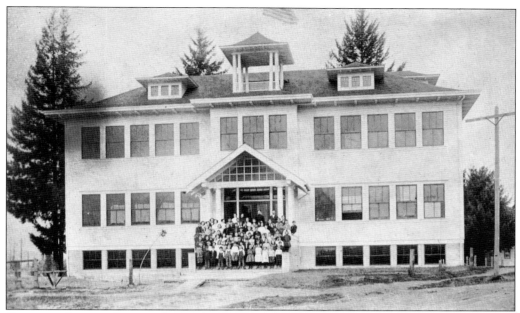

GRAMMAR SCHOOL, SHERWOOD. Pictured in the early 1900s is the public grammar school building in Sherwood. (AJS.)

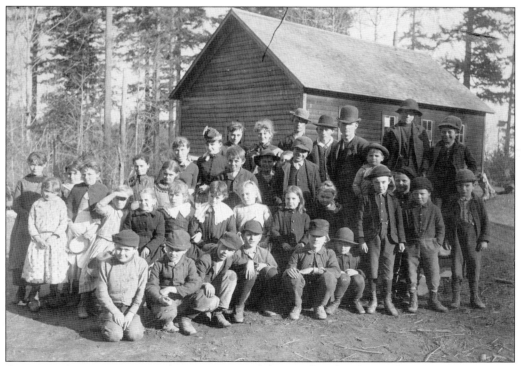

GRAMMAR SCHOOL, CIPOLE. This is an image of the Cipole School near Sherwood. This typical one-room schoolhouse housed students in many different grades. Cipole is located a few miles northeast of Sherwood. (WCM, 1,307.)

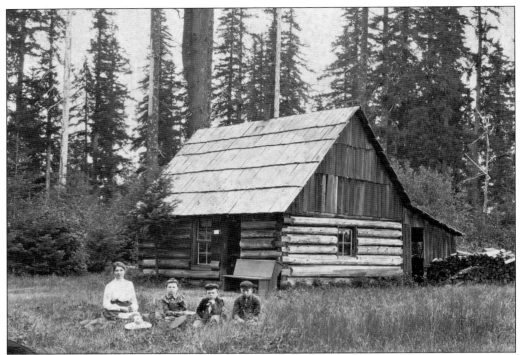

ONE-ROOM SCHOOL, TIMBER. This photograph, taken in 1902, shows the one-room log schoolhouse in Timber. The teacher in this photograph is Marion Schneider. The images of the Timber grammar school here and on the facing page show the typical evolution of school buildings in Washington County. (WCM, 1,327.)

SCHOOL CONSTRUCTION BIDS, TIMBER. Washington County placed a number of notices in the *Hillsboro Argus* of July 11, 1912, for contractors to submit bids for building new schools in its school districts. This is the notice for contractors to submit bids for the construction of a school building in the community of Timber. (AJS.)

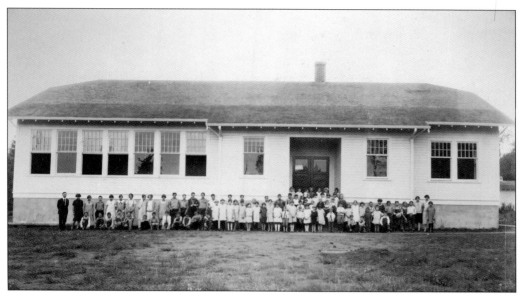

FINISHED SCHOOL, TIMBER. This photograph from September 20, 1926, shows Timber students and faculty posing in front of the school built by the contractor who submitted the winning bid. (WCM, 23,528.)

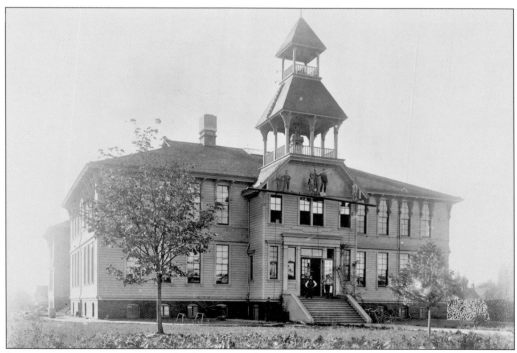

PUBLIC SCHOOL, HILLSBORO. The larger population of the county seat dictated a larger school building for all the students who would be attending. Workers are standing on a scaffold above the entrance to this ornate school building. (WCM, 1,232.)

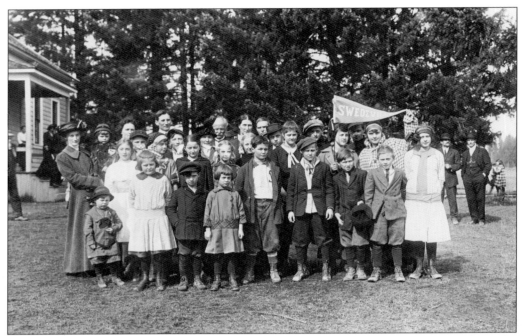

PUBLIC SCHOOL, SWEDEVILLE. Swedeville was a community centered where the Providence St. Vincent Hospital is now located. The community's name was derived from the large immigrant population from Sweden. (WCM, 15,786.)

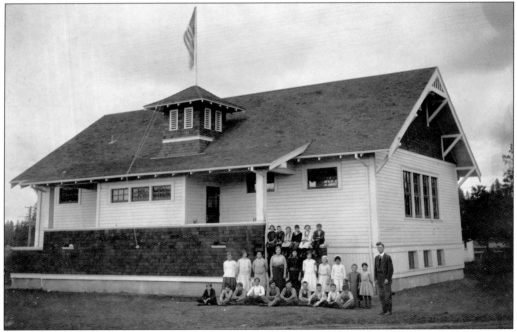

PUBLIC SCHOOL, WITCH HAZEL. Seen here is the grammar school building in Witch Hazel, which is just west of Reedville. The origin of Witch Hazel's name is one of those bits of local history that might never be fully resolved to everyone's satisfaction. (WCM, 12,320.)

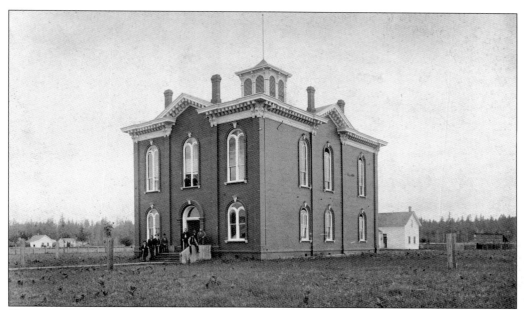

COURTHOUSE, HILLSBORO. The original Washington County Courthouse was a wooden structure. In the early 1870s, the county paid Samuel Elliott $12,500 to build this brick courthouse, which was finished in 1873. The small white building at the rear is the county jail. (WCM, 15,917.)

DEPRESSION-ERA SCRIP, WASHINGTON COUNTY. Scrip is a medium of exchange that is produced in place of federal currency. It can be made by a municipality, a bank, a business, or individual. As a result of the Great Depression in the 1930s, physical cash was scarce and many banks were closing down, making the use of scrip common in many areas of the country. The Washington County–issued scrip pictured here was printed by the *Hillsboro Argus* newspaper company. (AJS.)

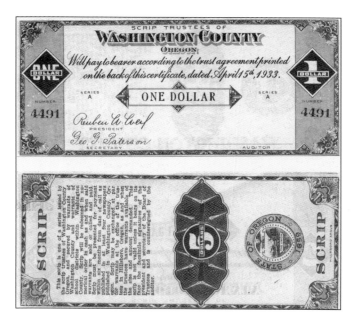

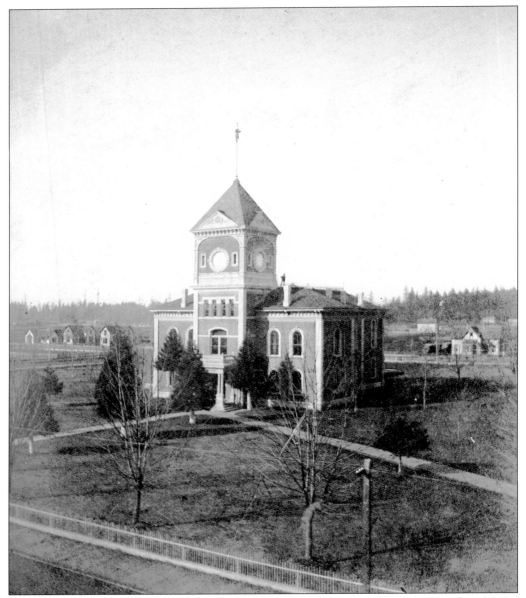

COURTHOUSE, HILLSBORO. Delos Neer of Portland was the architect hired to expand and modernize the original brick structure and install steam heating throughout for a cost of $20,000. The clock tower was finished in 1891. The city, however, never bought the mechanical works to be installed. This photograph of the remodeled courthouse shows how much empty land surrounded the building. One unusual feature of this image is that Orville Wilkes can be seen at the very top of the flagpole extending up from top of the new clock tower. Starting in 1903, Orville Wilkes (also seen on page 42 and 43) was the manager for the Hillsboro water and light plant. John Porter planted the redwood trees on the south side of the courthouse from seedlings; Porter brought two sacks of redwood cones to Washington County from his trip to the goldfields of California. (WCM, 431.)

GUILTY AS CHARGED, HILLSBORO. This is a photograph of Gustav Wachline, one of Washington County's more infamous criminals. John Ledrick, a local farmer, charged Wachline with the theft of a cow. Wachline went to the Oregon State Penitentiary for six months for that theft. When he got out of prison in April 1894, he returned to Ledrick's farm and bludgeoned him to death. Sheriff William Bradford spent almost four years tracking down Wachline, eventually receiving word that Wachline was working on a farm in Eastern Oregon. The sheriff rode east and captured Wachline after 10 days of riding and searching. Wachline was brought back to the Washington County Jail to await trial for Ledrick's murder. He was found guilty and sentenced to hang. Over 500 people were supposed to have come from all over to witness the execution on February 4, 1898. Wachline maintained he was innocent right up until the end. In 1908, William Bradford was committed to the insane asylum in Salem due to excessive drinking. (WCM, 1,518.)

JOHNSON PHOTOGRAPHY, HILLSBORO. Julian Eggleson Johnson was the owner of a popular photography studio in Hillsboro. This is a self-portrait appearing on an advertisement for his studio. Johnson was born in Wisconsin in 1861. He moved to Oregon in 1907 and ended up in Hillsboro in 1909, where he opened up a photography studio. He had a successful business, but he was arrested in 1921 for taking nude photographs of local young women. Before his arrest, his occupation was listed as photographer in the 1920 US Census. After his arrest, Johnson's occupation was listed as cleaner/presser in the 1930 US Census. The location of Johnson's photography studio on Main Street can be seen on page 27. In that image, his business sign is at the far right hanging out over the sidewalk. (WCM, 11,513.)

CITY HALL, HILLSBORO. As the seat of Washington County, Hillsboro was the site for the county courthouse. Hillsboro also had a large city hall building at Second and Washington Streets, which housed city offices. The large roll-up doors on the first floor were for the city firefighters' vehicles. (WCM, 15,334.)

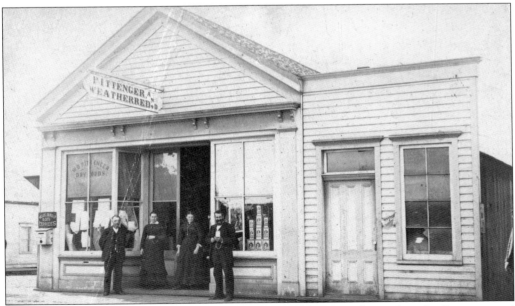

POST OFFICE, HILLSBORO. An early post office in Hillsboro was located in the Pittinger and Weatherred Building. Mary Abell Brown, standing in the door, was the town's first postmistress. Note the Wells Fargo Express drop box on the left corner of the building. (WCM, 1,071.)

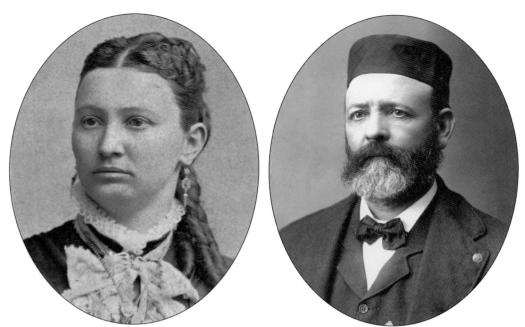

Two Post Office Executives, Hillsboro. Mary Abell Brown (left) was the Hillsboro postmistress from 1875 through 1896. Rufus Waggener (right) was the postmaster starting in 1900. He also operated the Tualatin Hotel in Hillsboro for 22 years before turning hotel operations over to his son Dorr Waggener. (Left, WCM, 225; right, WCM, 1,524.)

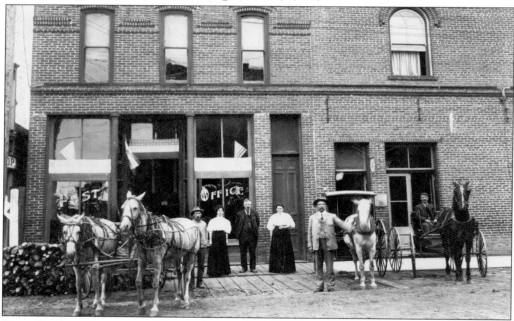

Post Office, Hillsboro. A later edition of the town's post office was located in this brick building on Second Street between Main and Washington Streets. Bertha Hesse, Ben Cornelius (appointed postmaster 1905), and Susie Morgan, who was Ben Cornelius's principal assistant, are among those standing outside on the sidewalk. (WCM, 1,085.)

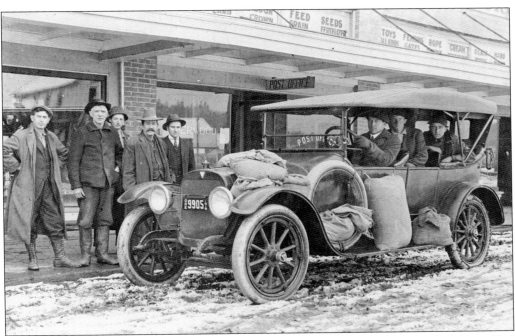

POST OFFICE, SHERWOOD. Sherwood's post office is seen behind the touring car, which has a 1916 license plate. It is unknown if the full bags are products purchased at a store or are simply serving as ballast to increase the tires' traction on the snow-covered roads. (WCM, 11,784.)

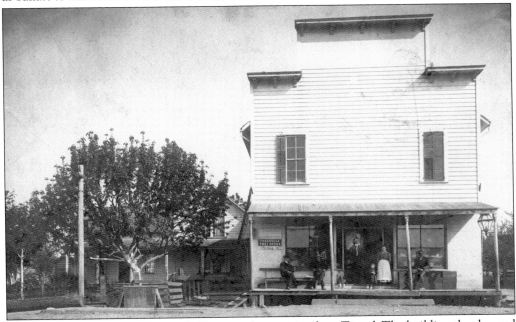

POST OFFICE, TIGARDVILLE. Tigardville is now known simply as Tigard. The building that housed the post office also served as a store. Post offices were often combined with other businesses, as the postal service preferred to avoid the expense of having to build a stand-alone post office in thousands of towns across America. (WCM, 1,736.)

POST OFFICE, FOREST GROVE. This 1940s photograph shows the Forest Grove Post Office on the first floor of the far left building, with the Grange hall on the second floor. (AJS.)

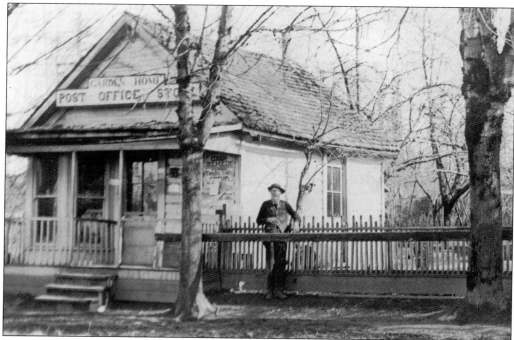

POST OFFICE, GARDEN HOME. Postmaster Lumen Nichols is standing outside the post office in Garden Home, located southeast of Beaverton. Nichols was born in Vermont in 1831. (WCM, 18,167.)

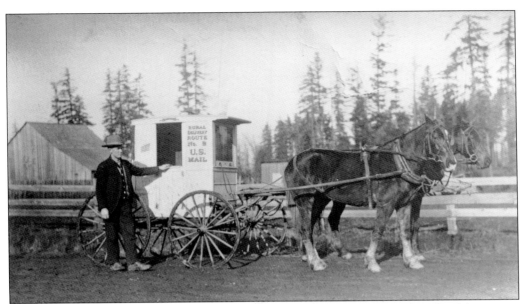

RURAL FREE DELIVERY, BEAVERTON. The "Rural Delivery Route No. 2" on the side of this wagon refers to Rural Free Delivery, which was a mail delivery service started in 1896 by the US Postal Service to get mail to the many farmers and ranchers living outside a town's boundaries. (WCM, 3,322.)

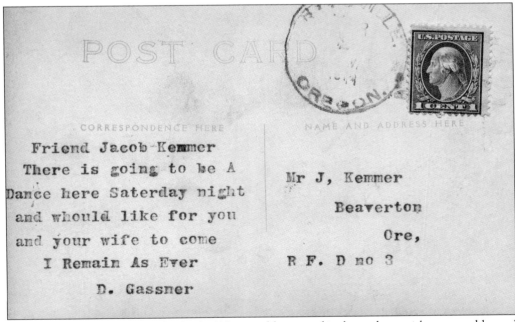

POSTCARD, BEAVERTON. The back of a 110-year-old postcard is shown here with a note addressed to a friend of the sender. The address is for Rural Free Delivery route No. 3 in the Beaverton area. Prior to the RFD service, people living in rural areas had to come to town to pick up their mail. (AJS.)

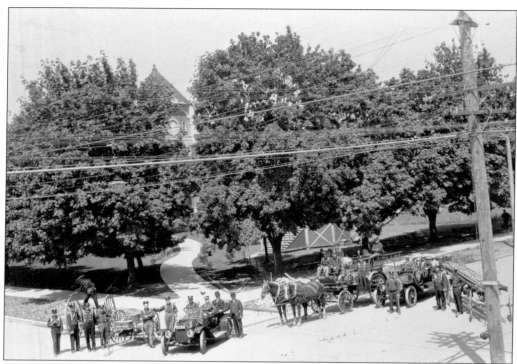

FIRE DEPARTMENT, HILLSBORO. Members of the fire department and their equipment are posed right in the middle of the intersection. The county courthouse building can be seen peeking through the trees in the background. (WCM, 562.)

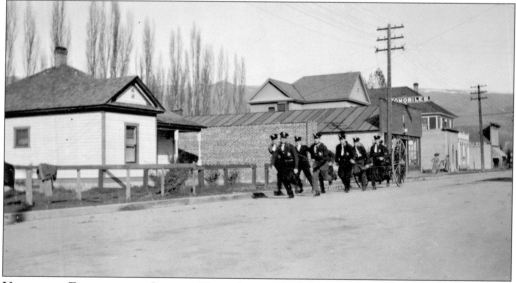

VOLUNTEER FIREFIGHTERS, GASTON. The volunteer firefighters of Gaston are pulling the town's hose cart down the street. The hand-drawn cart was bought in 1900. It would take too long to harness a team of horses and hitch them to the cart, so the firefighters provided the horsepower. A sign for the town's Temple Hotel can be seen in the distance. (AJS.)

Nine

WASHINGTON COUNTY PETS

This last chapter has images of Washington County people and their pets. The most common pets were cats, dogs, and horses. Many of the pets had a job. Cats were used to keep rodents out of barns and homes. Dogs were used for protection and hunting. Prior to the advent of gas-powered machines, horses were the main source of power and transportation. To help stop the abuse of draft animals, Thomas Lamb Eliot founded the Oregon Humane Society (OHS) in Portland in 1868. The OHS is one of the oldest humane societies in the nation and is celebrating its 150th anniversary in 2018. The OHS is the largest humane society in the Northwest and adopts more animals from its Portland shelter than any other single-facility shelter on the West Coast.

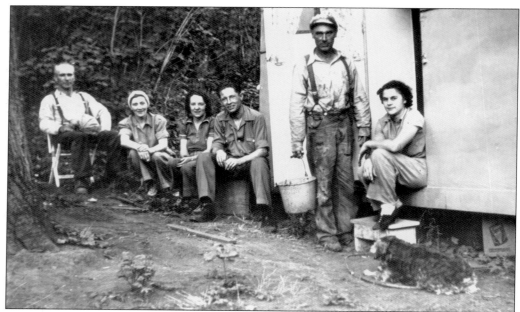

LOUISE STOVALL, SNOOSEVILLE. Louise and her dog are at far right in this 1933 group photograph. Stovall was a logging truck driver, a school bus driver for Banks children, and a passenger bus driver for the Snooseville-to-Portland route. She was the only person with a chauffeur's license in the area at the time. Snooseville is in the northern part of Washington County, just southeast of Bacona. (WCM, 16,863.)

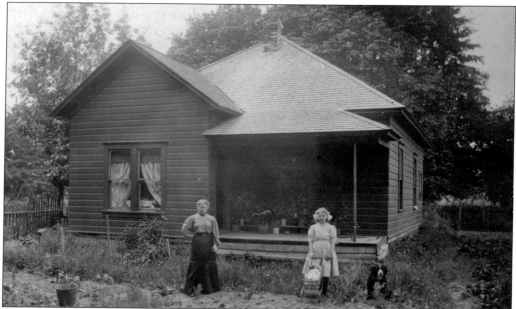

GRABEL FAMILY, HILLSBORO. This 1911 photograph shows Elizabeth Grabel outside her home in Hillsboro. Her husband, John, passed away in 1909. Elizabeth's daughter Isa May is holding onto a baby buggy with Ernestine the doll inside. Jack the family dog is included in the family photograph. (WCM, 28,075.)

BEN HARMS, NORTH PLAINS. Young Ben Harms of North Plains was born in 1906. Here, he is proudly showing off two of his family's horses. Ben's parents, Henry and Elma, owned a large farm. (AJS.)

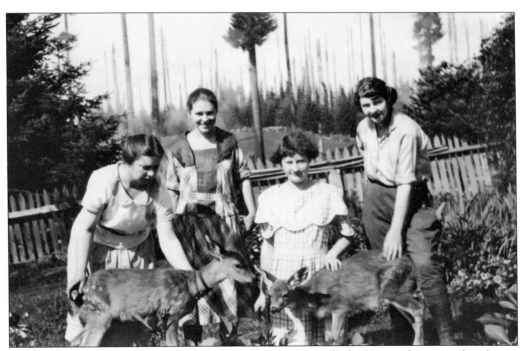

BABY DEER, BACONA. Four young ladies are in the backyard of a Bacona homestead with two fawns. (WCM, 28,058.)

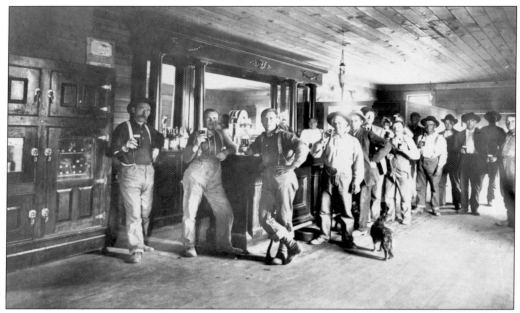

SIMPSON'S SALOON, BUXTON. Since having enough light to expose the negative was often difficult, photographing the interiors of buildings was not that common in the late 19th and early 20th centuries. This image is of the interior of Robert Simpson's saloon. The saloonkeeper's dog is seen walking away from the photographer. (WCM, 9,792.)

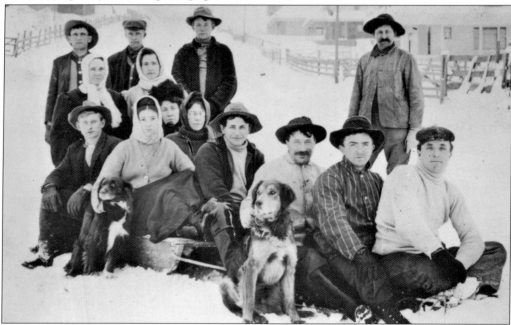

SLEDDING CARSTENS HILL, BANKS. A large group of Banks residents and their dogs are out sledding down Carstens Hill, which is behind them. The young man standing at far left is Robert Banks, one of the sons of the town's namesake. Standing third from left is a son of the Carstens family, the namesake for the hill behind the group. (WCM.)

PIGS ON THE FARM, BEAVERTON. Alice Denney is seen with three of the family pigs on the site of her great-grandfather Thomas Denney's Donation Land Claim of 640 acres in Beaverton. Alice was born on May 1, 1925, and is probably five years old in this photograph. (Courtesy of Judy Donovan.)

HINTON FAMILY, LAUREL. Mr. and Mrs. Sam Hinton of Laurel are standing on the front porch of their log home. This photograph was taken in 1901. Laurel is due east of Gaston. (WCM, 852.)

A Good Day, Washington County. The women have the bird guns on their shoulders, and the men are holding fishing rods. It was a good day hunting and fishing in Washington County, as evidenced by the string of both birds and fish. The group's bird dog is posed right in the middle. (WCM, 3,494.)

Storm Damage, Hillsboro. A woman with her dog is talking to an insurance adjuster about the wind damage on her property because of the Columbus Day Storm of October 1962. That storm did major damage, bringing down hundreds of trees throughout Washington County. (WCM, 12, 677.)

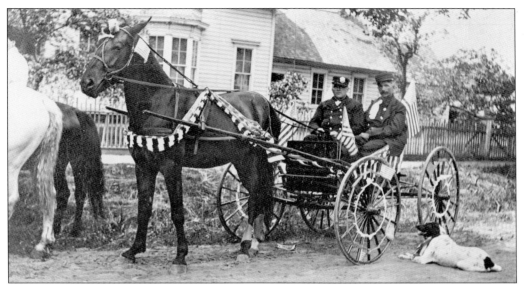

FOURTH OF JULY, FOREST GROVE. This photograph is showing either the beginning or end of a July 4, 1911, parade in Forest Grove. Dogs have been associated with fire departments going back to the 18th century. The dogs would often guard the firehouse and guard the fire equipment at the scene of a fire. (WCM, 18,154.)

MAN AND HIS CAT, WASHINGTON COUNTY. This unidentified man is proudly balancing the family cat on the palm of his hand, while his family members are relegated to sitting on the porch steps in the background. (WCM.)

GROUP PHOTOGRAPH, HILLSBORO. This c. 1890 photograph, taken at the Crandall photography studio, shows, from left to right, William McCourt, William Wiley, and Gus Bailey. The dog's name was not provided on the back of the photograph. Wiley owned a saloon in Hillsboro, as seen on pages 44 and 45. (WCM, 1,573.)

INDEX

Please note that not all the people and places appearing in this book are listed in this index.

DISCOVER THOUSANDS OF LOCAL HISTORY BOOKS
FEATURING MILLIONS OF VINTAGE IMAGES

Arcadia Publishing, the leading local history publisher in the United States, is committed to making history accessible and meaningful through publishing books that celebrate and preserve the heritage of America's people and places.

Find more books like this at
www.arcadiapublishing.com

Search for your hometown history, your old stomping grounds, and even your favorite sports team.